ODDEE PRESENTS

MAKING BAD PICTURES GREAT AND GOOD PICTURES AWESOMELY BAD

PHOTOBOMB [fo-to_bom]

(verb or noun) To ruin other people's photos by making silly faces and/or moving into the background or foreground immediately before the photos are taken, often unbeknownst to the other people in the picture.

BEVERLY L. JENKINS

sourcebooks

Published by Sourcebooks, Inc.
P.O. Box 4410, Naperville, Illinois 60567-4410
(630) 961-3900
Fax: (630) 961-2168
www.sourcebooks.com

Library of Congress Cataloging-in-Publication Data
Jenkins, Beverly L.
 Photobombed! : making bad pictures great and good pictures awesomely bad / Beverly L. Jenkins.
 At head of title: Oddee presents
 "Photobomb [fo-to_bom] (verb or noun) To ruin other people's photos by making silly faces and/or moving into the background or foreground immediately before the photos are taken, often unbeknownst to the other people in the picture."
 (trade paper : alk. paper) 1. Photography, Humorous. I. Oddee (Electronic resource) II. Title.
 TR679.5.J46 2012
 770.2'07--dc23

2012011961

Printed and bound in China

OGP 10 9 8 7 6 5 4 3 2 1

chapter selections

7. WEDDING BOMBS
Memories you'll always remember, whether you want to or not.

8. KID BOMBS
No one can trash a picture faster than your bundle of joy.

9. DAD BOMBS
Patriarchs who make us proud.

10. BEACH BOMBS
Just a thin strip of nylon between your nooks & crannies and the world…

11. TMI BOMBS
Too much information? There's no such thing.

12. PEEK-A-BOMBS
A little glimpse of hilarity where you least expect it.

13. COSTUME BOMBS
We can dress them up, but still can't take them anywhere.

14. WTF BOMBS
What the f#@k is going on here? We haven't a clue.

 introduction

PHOTOBOMB [fo-to_bom]
(verb or noun) To ruin other people's photos by making silly faces and/or moving into the background or foreground immediately before the photos are taken, often unbeknownst to the other people in the picture.

Have you ever looked at one of your photos and found a grinning, devil horn-flashing stranger peering over your shoulder? Congratulations! You've just been photobombed.

Photobombing isn't a new concept; we believe photobombs have been around since the invention of the camera. In fact, we have photographic proof; check out this picture taken in 1880:

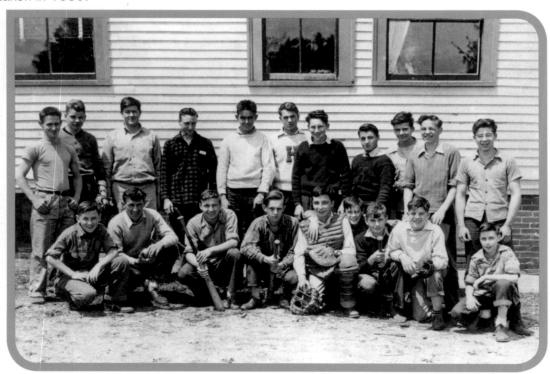

Did you spot the photobomber?

Here's a hint: this sullen little girl looks like she's thinking, "Fine, I didn't want to be in

your stupid picture anyhow!" Even though times and technology have changed, the art of photobombing has been practiced either intentionally or accidentally for generations, and we thought it was high time there was a book to document this pop-culture trend, and we're just the folks to write such a book.

Oddee is an entertainment blog focusing on everything weird, funny, bizarre, and yes, odd in our world, and we have covered the topic of photobombing many times since we started writing daily lists back in 2006. In fact, when we decided to venture into print publication it didn't take us long to choose photobombing as our first book topic, because these posts are consistently popular among our readers, and the reason they're popular is simple: photobombs are hilarious! It's just undeniably funny to see a perfectly normal picture being ruined by a glaring baby, a dog with laser beam eyes, or the best man making a crazy face while the bride and groom cut their cake.

It wasn't enough for us to simply tackle photobombing in book form; we also decided to make our readers a part of the experience! We didn't want to show you the same classic photobomb pictures that have been circulating around the Web for the past few years. We wanted to give you all-new bombs that had never been published before. We decided to give the literary world the quintessential book about photobombing; a book that covers all of the different ways to crash a picture; a book that celebrates the art of photobombing and the hilarious people who do it; but most of all, we wanted our readers to be the stars of the show! We collected the pictures in this book from our vast worldwide audience, and when all was said and done we had gathered almost three hundred photos from every corner of the globe, all for your amusement.

In this book you'll see every kind of photobomb imaginable, from your average interloping stranger to animated TV characters to a self-pleasuring walrus. Yes, really! We couldn't make this stuff up if we tried.

Thanks to all of our readers who visit us at *Oddee* every day, and thanks especially to the funny folks who sent us their pictures and helped us bring this book from concept to reality. We hope that you enjoy seeing your fellow *Oddee* fans from near and far making bad pictures great and good pictures awesomely bad!

photo credits

This book would not exist without the creativity, good humor, and generosity of these talented photographers:

Abdul Harith	Amadeus Hellequin	Bill Keaggy
Abigail Smith	Amy Everson	Bob Sherron
Adam Leo	Amy Laurenti	Branden Birmingham
Adrian Boutelje	Anna Kohls-Dangremond	Brenton Woo
Alex Kuhse	Ashley Estes	Bret Watkins
Alicia Broederdorf	Augie Rivera	Carl Gustaf vonPlaten
Alma Lopez	Beverly Jenkins	Carla Ailshie

Cassi Drew

Chris Olds

Chris Shea

Christopher Patterson

CK Egan

Court Fher

Cristina Castro

Cristy Abaton

Damien Howley

David Carter

David Meechan

Derek Young

Diana Cousminer

Diane Cepa

Dione Wood Milauskas

Doctress Julia Bedford

Elli Kalei

Ellis Evans

Emily Kwong

Eric Hacke

Eric Jasso

Eryn Smith

Fahad Alki

Frank Irwin

Fred Parker

Gabriel Carapeba

Gagan Sihota

George M. Wilson IV

Glenn Carrington

Gordon Barr

H Doodson

Hadlet Zamperini

Heidi Goldstein

Holly Copeland

Jacinta Beer

Jaime Villanueva

Jane Rinsky

Jasmine Tellier

Jason McGorty

Jay-r Trinidad

Jennifer Morrow

Jesse Bearden

Jessica Gross

Jessie Heap

Jessy Stewart

Joanna Jefferson

John Dulak

Joydeep Roy

Judie Lipsett Stanford

Julie Szabo

Kaise Arciaga

Kariel Watkins Mile

Kate Ballard

Katherine Hawkes

Katie Jenson

Kay Reynolds

Keeley Lyons

Kelsey Patton

Keri Carter

Kerry Meyers

Kevin Kelly Walker

Kris Miethner

Kylie Lipsitz

Laura Taverner

Lauren Johnson

Leonor Siao

Leslie Gomez

Leslie Parrish

Lizzy Bunton

Luke Martin

Lydia Evans

Maithili Mokashi

Mala Tyler

Maria Favia

Marilyn Ramirez

Mark Laizure

Mark Pilloff

Martha Mills

Mary Lewey

Mary Wagner

Matt Munce

Maureen Higgins

Maureen Smith

Melissa DeGarmo

Metal Jeff Rogers

Michael Biscombe

Micky Myers

Mikkel Glarbo

Morgan Cable

Nadia Mohiuddin

Nardeana Nop

Nathan Winder

Nicholai Go

Nyssa Silvester

Philadelphia Robinson

Rachel M. Campbell

Raelene Gutierrez

Rick Christ

Rosa Escandon

Ryan O'Quinn, www.flickr.com/rdogxtreme

Sam Middler

Samantha Dipiero

Sean Townsend

Shannon Woulahan

Shell Feda

Sophie Watkins

Stephanie Harrington

Susan Keller

Tara Lindsey

Tawna Gawley

Vanessa Christensen

Vienna Vance

Zan Campbell-Vincent

 # stranger bombs

The classic Stranger Bomb is the gold standard of photobombing. There are two kinds of Stranger Bombs: intentional and accidental—kind of like pregnancies. Intentional Stranger Bombs are the work of those exhibitionist types who think that all pictures can be improved by their grinning faces. They're the people who purposely ruin photos for sport, and without them the world would be a much more boring place.

Then there are the accidental Stranger Bombs, which are equally funny but in a different way; these folks are just going about their business when they happen to wander into your shot. They're the benign, slack-jawed, clueless types who didn't mean to spoil your shot, they were just…*there*, usually staring blankly as if mentally they're a thousand miles away, picking daisies in a field. But they're not picking daisies; they're in your picture. Forever.

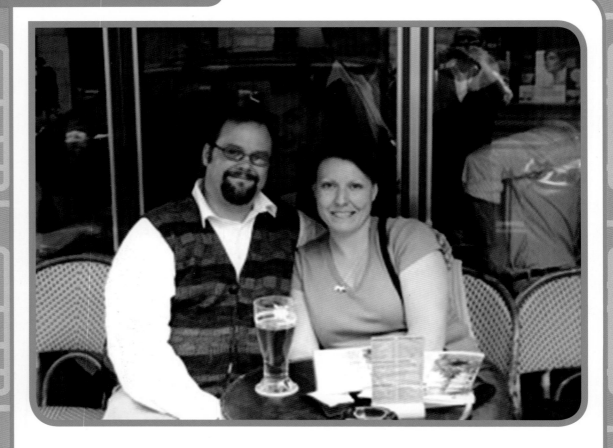

PARIS IS FOR LOVERS...AND THESE GUYS.

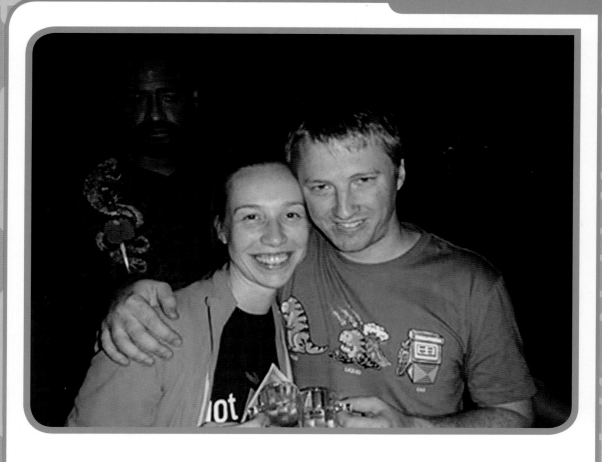

"Guys, maybe I shouldn't have drunk all that cough syrup..."

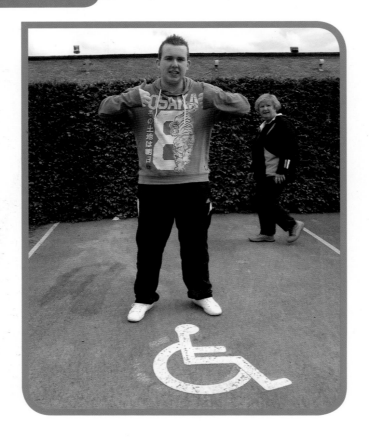

IMMEDIATELY AFTER THIS PHOTO WAS TAKEN,
THIS LADY TOLD HIM TO GET THE HECK OUT
OF HER PARKING SPACE. TRUE STORY.

IS IT COLD IN THERE, OR IS IT JUST
THIS CREEPER'S ICY STARE?

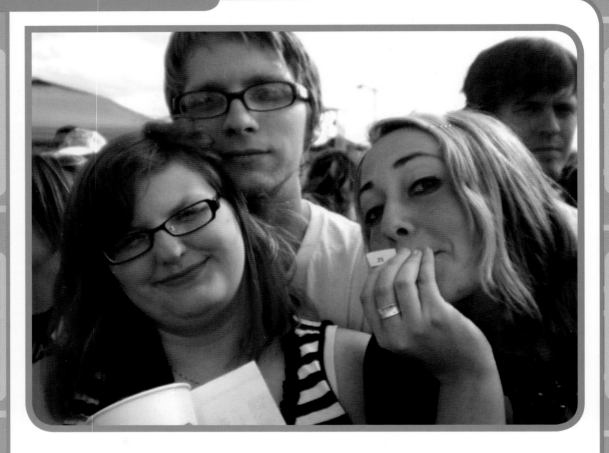

"I WILL BOMB YOUR PHOTO,
BUT I WON'T BE HAPPY ABOUT IT."

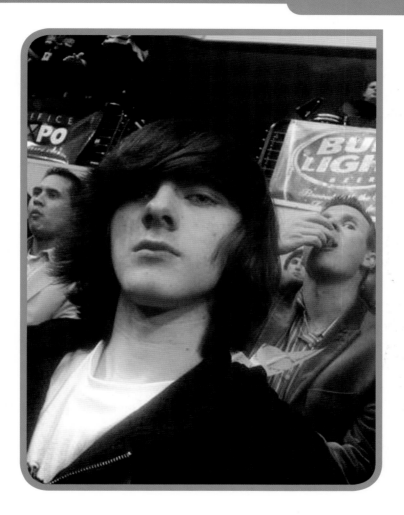

EMO-BOY IS NOT AMUSED BY YOUR GLUTTONOUS ANTICS.

PEACE, LOVE, AND NASCAR

TROLL-FACE FOR THE WIN!

CHEER UP, GRUMPY ROLLER-COASTER GUY.
THE RIDE IS ALMOST OVER!

FINGER-LICKIN' PHOTOBOMB.

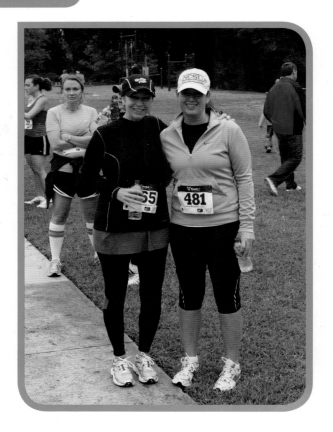

WE UNDERSTAND, LADY IN PINK—RUNNING
MAKES US GRUMPY, TOO.
P.S. NICE TUBE SOCKS.

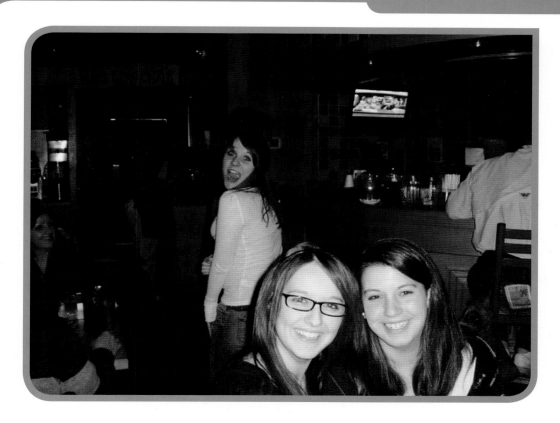

"OH, HI!"

IN CASE YOU'VE BEEN WONDERING WHAT
EDDIE VEDDER HAS BEEN UP TO LATELY...

IF YOU DON'T LIKE HER DRESS, JUST SAY SO!
NO NEED TO BE SO CATTY.

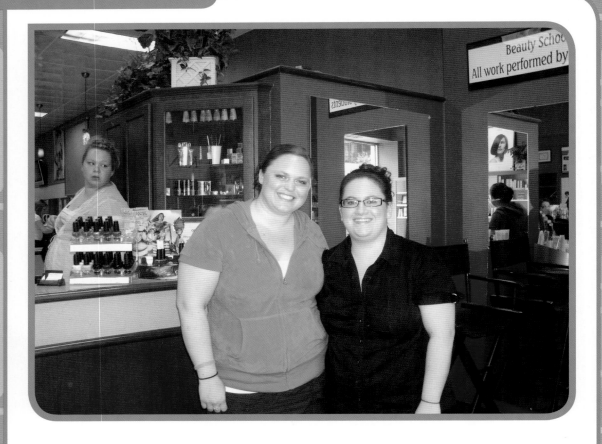

"YOU GUYS SAY, 'CHEESE,' AND I'LL SAY,
'DUUUURRR.' SOUND GOOD?"

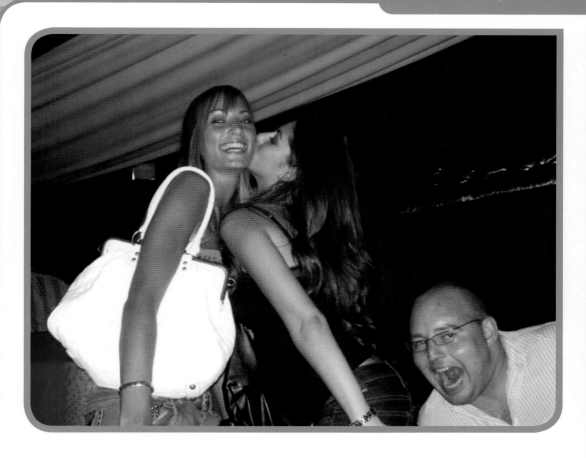

HE JUST WANTS TO "ASS" HER A FEW QUESTIONS.

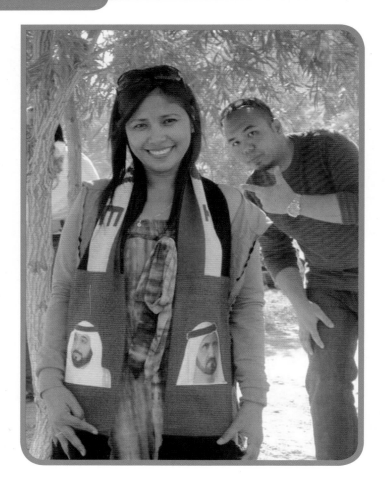

WE DIDN'T THINK IT WAS POSSIBLE
TO BE PHOTOBOMBED BY AN ARTICLE
OF CLOTHING, YET HERE WE ARE.

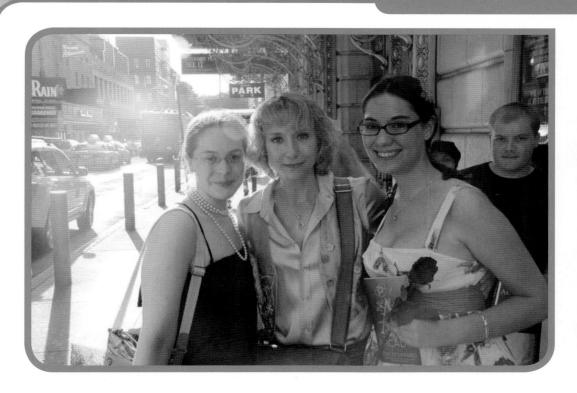

"HELLO LADIES...DON'T BE ALARMED. I HAVEN'T
BEEN FOLLOWING YOU AROUND THE CITY AT ALL.
WELL, OKAY, MAYBE A LITTLE BIT. BY THE WAY,
YOUR HAIR SMELLS TERRIFIC; IS THAT SUAVE?"

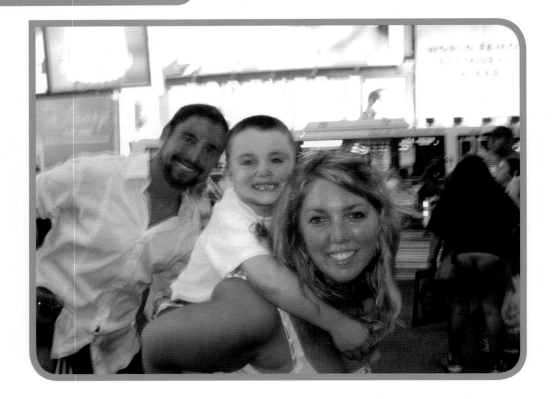

TWO PHOTOBOMBS IN ONE! HERE'S LAURIE AND HER NEPHEW GETTING BOMBED BY A HANDSOME STRANGER...AND BY THE WEDGIE THAT ATE NEW YORK.

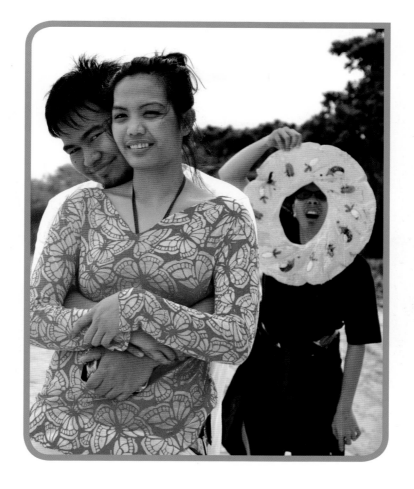

DAMN YOU, BEACHCOMBING STRANGER!

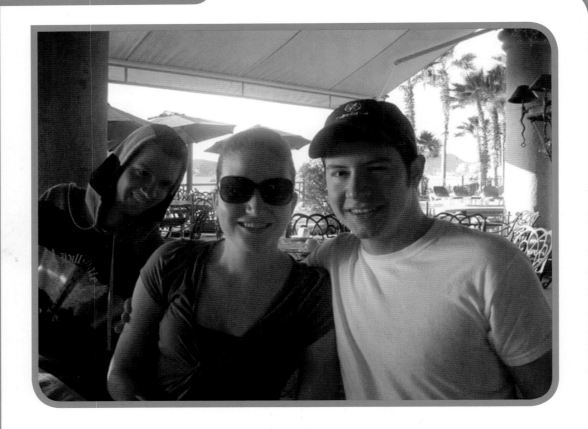

LOOKS LIKE A NICE PLACE TO VISIT...
IN SPITE OF THE WEIRD LOCALS.

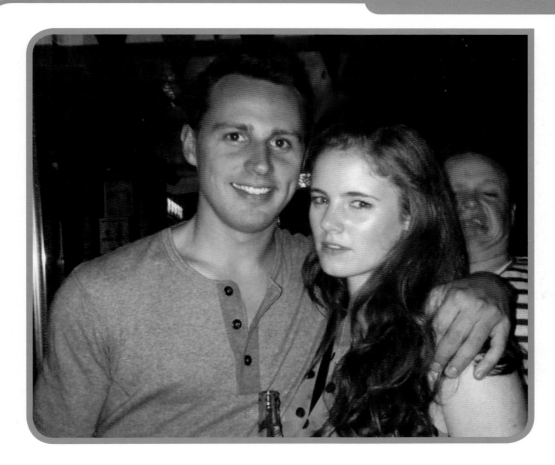

"THIS PICTURE WAS TOO ATTRACTIVE, SO I FIXED IT."

 # animal bombs

We love animals, and not just the tasty kind that we can eat. We love all creatures, great and small; they're unpredictable and they don't give a flaming falafel about appearances. They go where they want, when they want, and they don't care about you or your picture in the slightest—that makes them nature's original photobombers!

In this chapter you'll find all sorts of animals, both wild and domestic, popping up to say *howdy* in the funniest, strangest, and most random ways imaginable. We'd warn you about the nudity, but we're pretty sure that we've seen worse things in an eighth grade science video, so we think you can handle a little elephant dong. (Not that there's anything little about it.) See for yourself—they don't call it the "wild kingdom" for nothing!

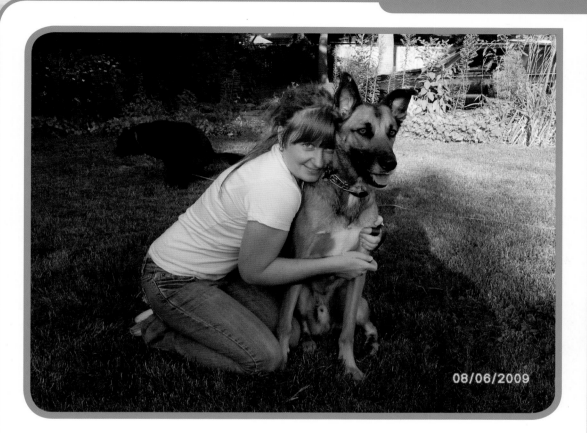

08/06/2009

WHAT A TENDER MOMENT...FOR HIM TO POOP ON!

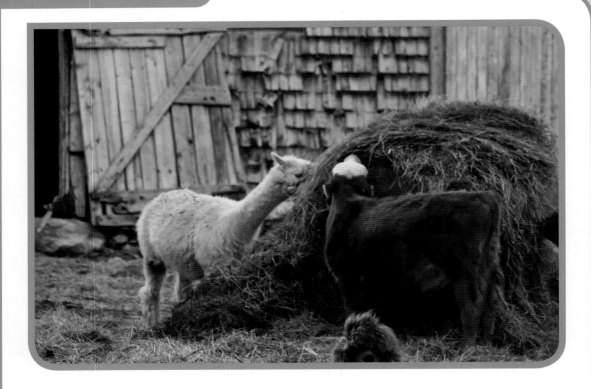

"WHATCHOO GUYS DOIN'? EATIN' SOME HAY?"

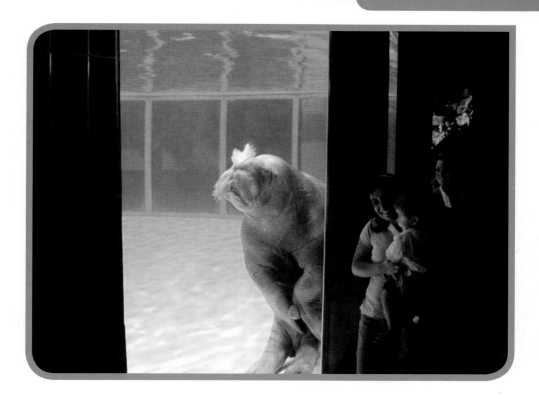

WHAT DOES A WALRUS HAVE TO DO
TO GET SOME PRIVACY? SHEESH!

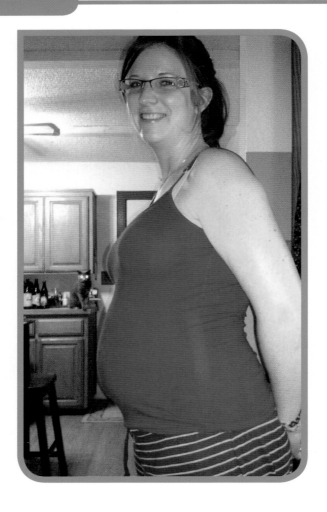

LASER-BEAM CAT CAN'T WAIT TO EAT MEET YOUR
BABY...BUT HE IS PATIENT. OH, SO PATIENT.

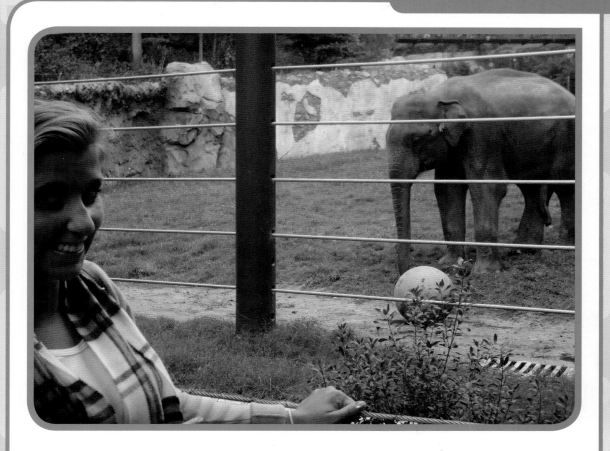

ELEPHANTS: MAKING OTHER MAMMALS FEEL
INADEQUATE SINCE THE DAWN OF TIME.

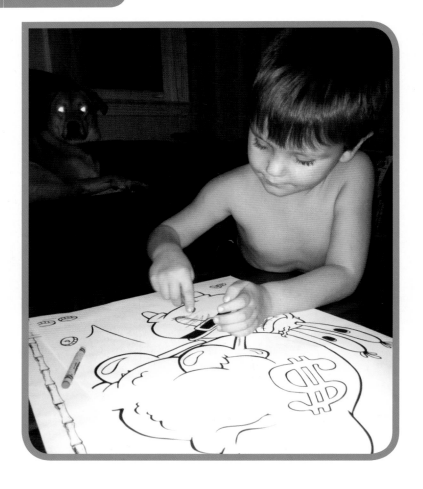

BEWARE OF THE DEMONIC DOG...
HE KNOWS WHERE YOU SLEEP.

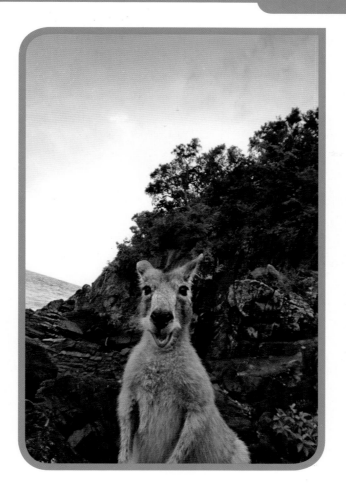

"G'DAY, MATE! YOU WEREN'T TAKING A PICTURE
OF THIS SCENIC VISTA, WERE YOU? NAH, WHY WOULD YOU DO THAT
WHEN YOU COULD HAVE A PHOTO OF ME INSTEAD?"

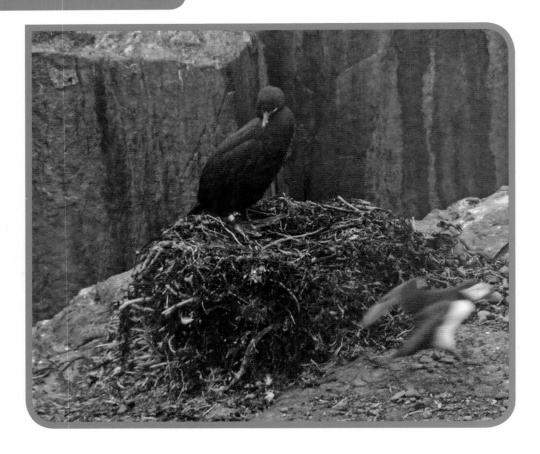

PUFFIN STREAKER!

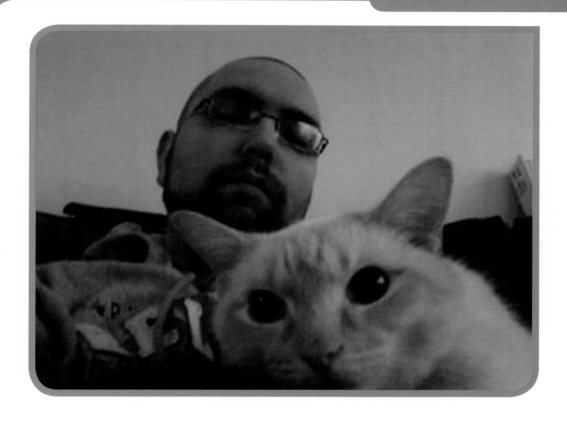

"I SHALL USE MY CATLIKE REFLEXES TO
POP INTO HIS WEB CHAT UNANNOUNCED..."

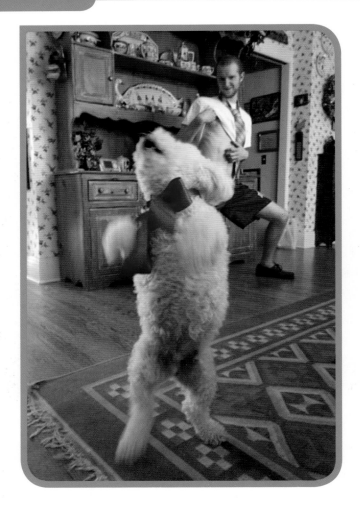

THEY DO SAY THAT PETS TEND TO RESEMBLE THEIR OWNERS...

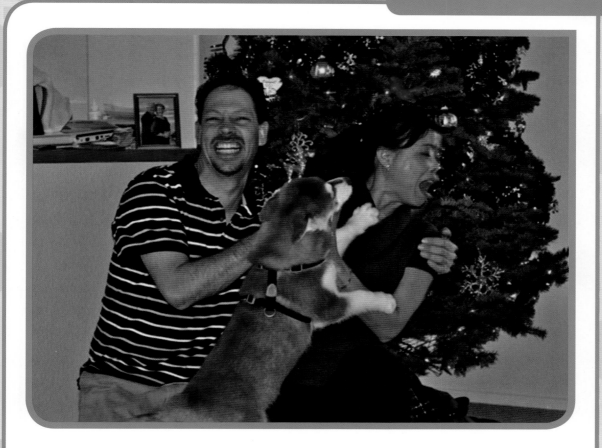

PUPPY BOMB!

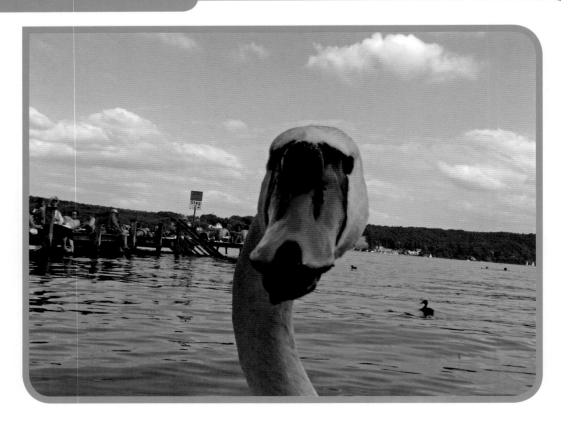

"HELLO!"

TAKE IT FROM US, USING YOUR PUSSY AS A PROFILE PICTURE IS A GOOD WAY TO GET YOURSELF KICKED OFF OF FACEBOOK.

 # student bombs

They say that education is wasted on the young, and this chapter proves that "they" are absolutely correct—whoever they are. Aw, we're just kidding! The fine young students in this chapter are inserting some much-needed levity into their days of pencils, books, and teachers' dirty looks, and we're glad they're keeping it real (and funny).

We received student bombs from everywhere from a private school in the Philippines to one of the largest universities on the East Coast of the U.S.A. We've got students getting bombed by teachers, students getting bombed at graduations, and students just, well, getting bombed. It's okay, we don't judge…and we promised not to tell their parents either, so put it in the vault.

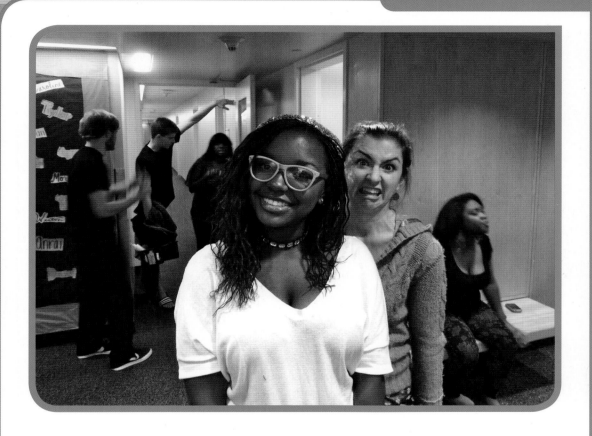

MAYBE YELLOW IS NOT YOUR COLOR.

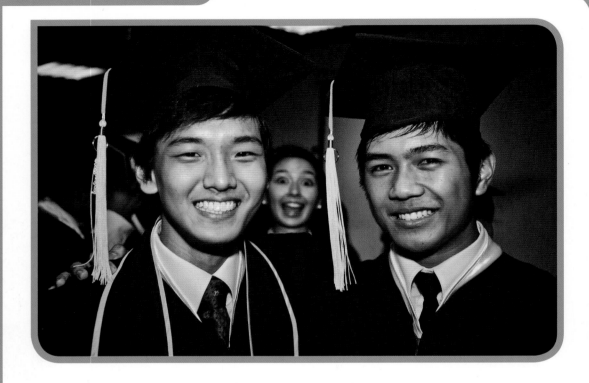

GRADUATING IS EXCITING!
REALLY EXCITING, FOR SOME PEOPLE.

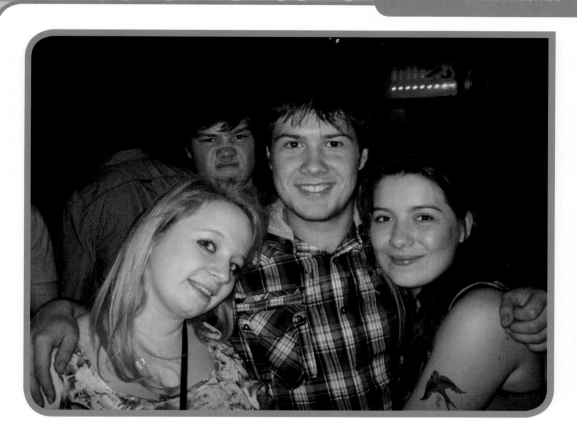

FIVE SECONDS LATER, THE GIRLS SMELLED IT TOO.

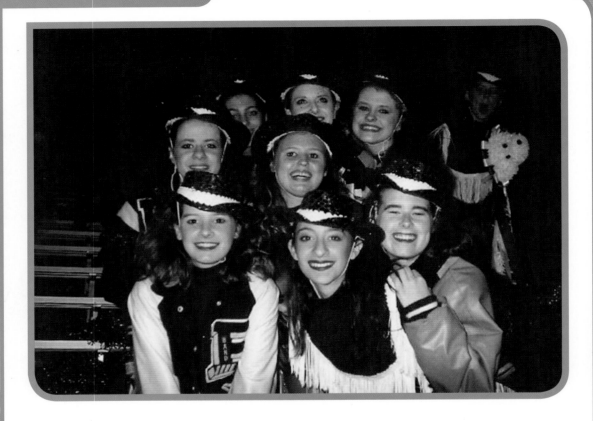

SHE'S NOT EVEN ON THE PEP SQUAD, SHE JUST SHOWS UP
AT GAMES DRESSED IN A UNIFORM. IT'S SAD, REALLY.

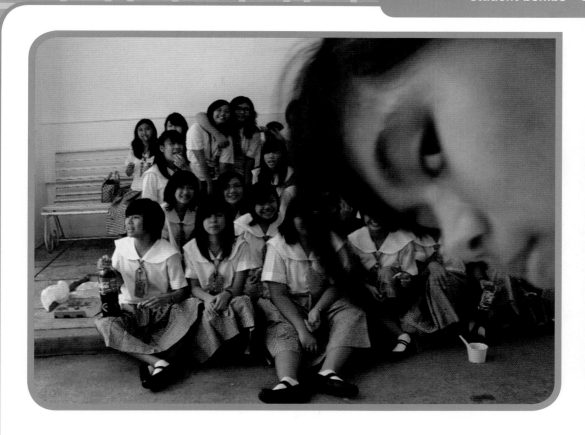

IS THIS THING ON?

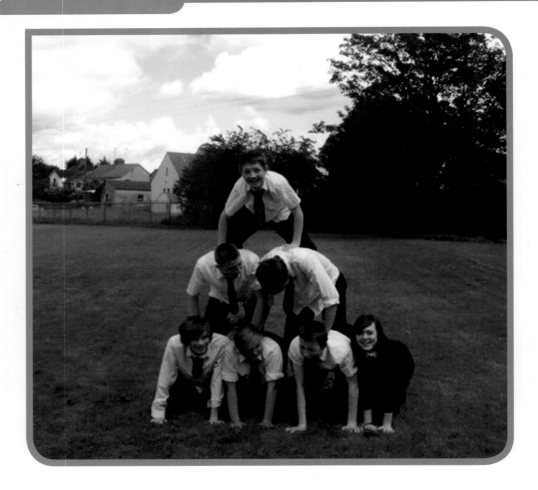

SHANNON PREFERS NOT TO BE
A LOAD-BEARING SECTION OF THE PYRAMID.

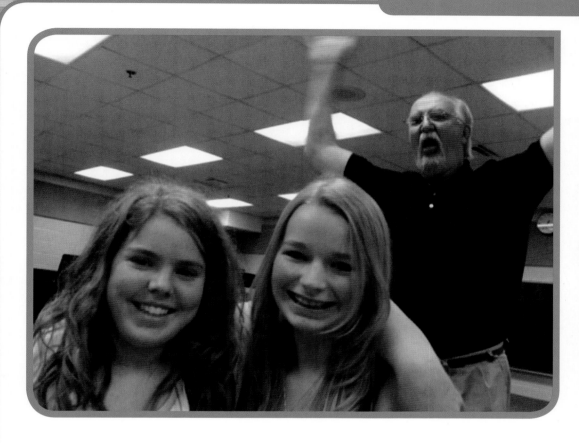

TEACHER SMASH!

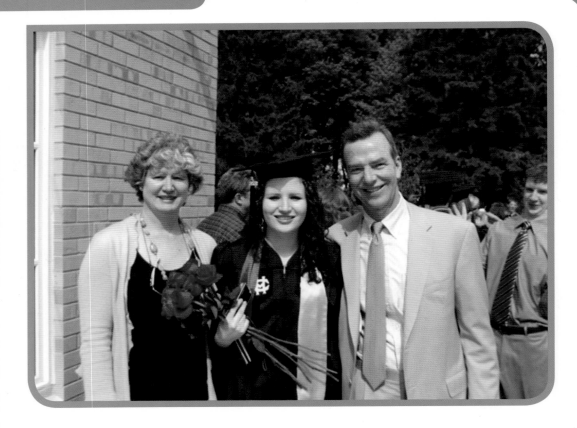

JUST ANOTHER PRICELESS FAMILY MEMORY:
MOM, DAD, DAUGHTER, AND THE ILLEGITIMATE
SON NO ONE LIKES TO TALK ABOUT. SWEET.

FOREVER ALONE...

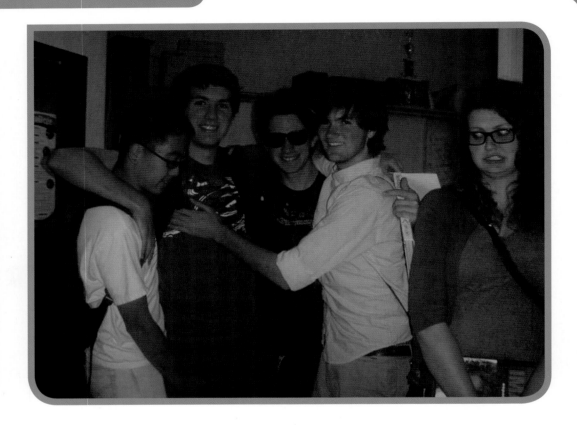

When Rosa sneaked into the boys' dormitory, she saw some crazy things. Crazy, dirty, unspeakable things.

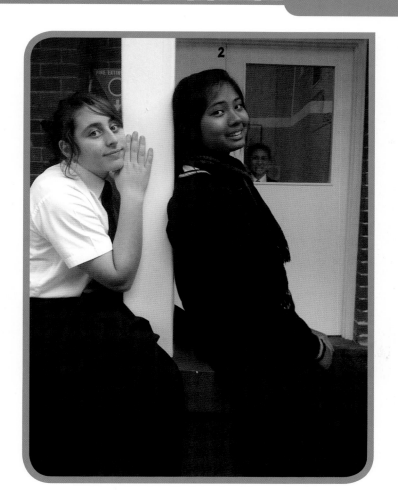

"YOU'RE TAKING THE PICTURE WITHOUT ME?!?!?"

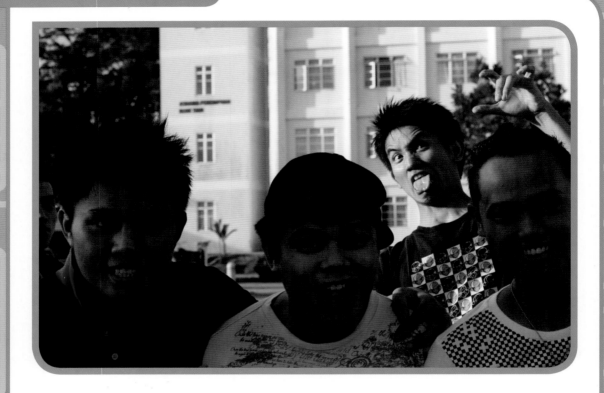

THERE'S ONE IN EVERY GROUP.

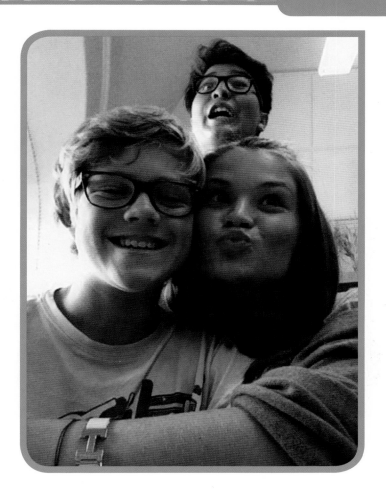

WAS THERE A TWO-FOR-ONE DEAL
ON HIPSTER GLASSES SOMEWHERE?

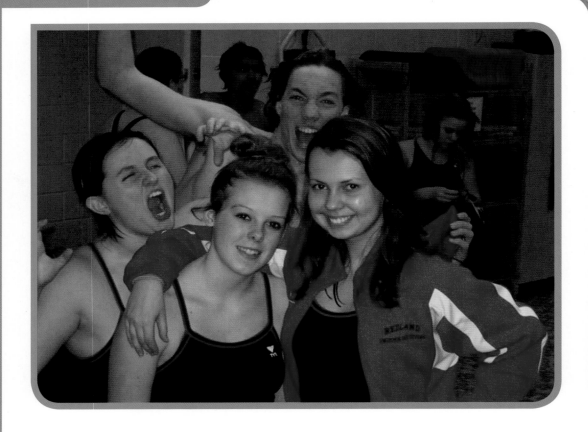

WHY YOU SHOULD NEVER DRINK FROM THE PUBLIC POOL.

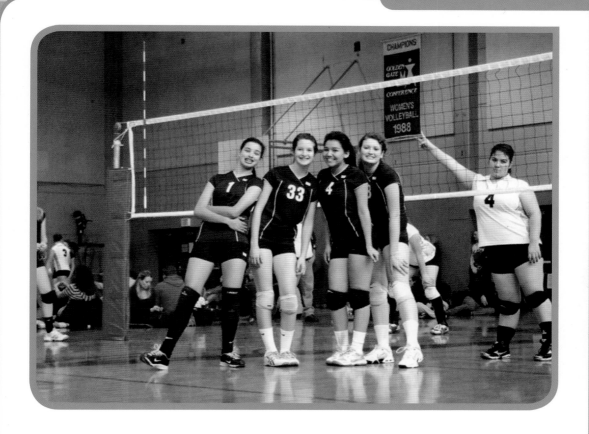

SHE MUST THINK HER ARM IS REEEEEEAALLY LONG.

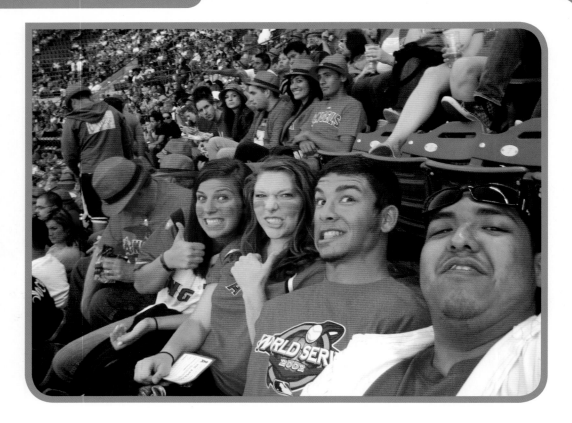

YOU MIGHT NOT SEE HER...BUT SHE SEES YOU!

bff bombs

We love our friends, and having BFFs (best friends forever) is definitely something for which we are very grateful. The only thing we don't entirely understand is why, when best friends get together, we feel the need to squish our faces together and take countless photos at varying unflattering angles. We suppose it's just human nature.

The good news is that often when two besties take the long-armed self-portrait or have another friend document their chumminess, a photobomber decides to creep into the lovefest unannounced…and fortunately for us, hilarity ensues!

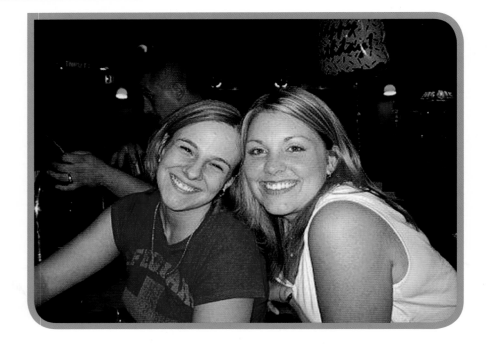

AMY'S HUSBAND JUST GOT THE BILL.
GUESS WE SHOULDN'T HAVE PUT ALL OF THOSE
ORDERS OF JALAPEÑO POPPERS ON HIS TAB.

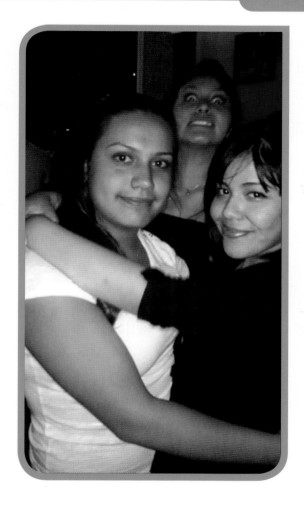

"I REFUSE TO BE IGNORED!"

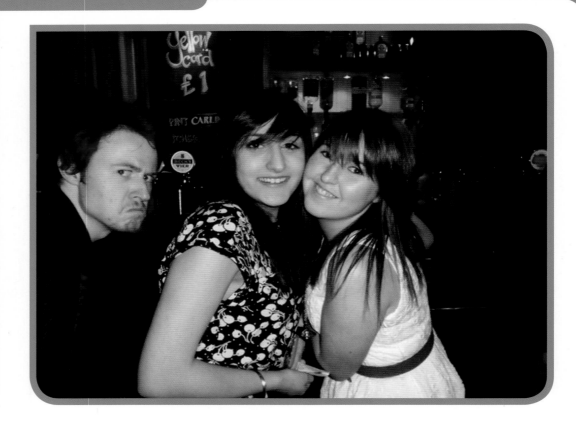

LADIES, HAVE YOU HUGGED YOUR REDHEAD TODAY?
HE LOOKS LIKE HE COULD USE ONE.

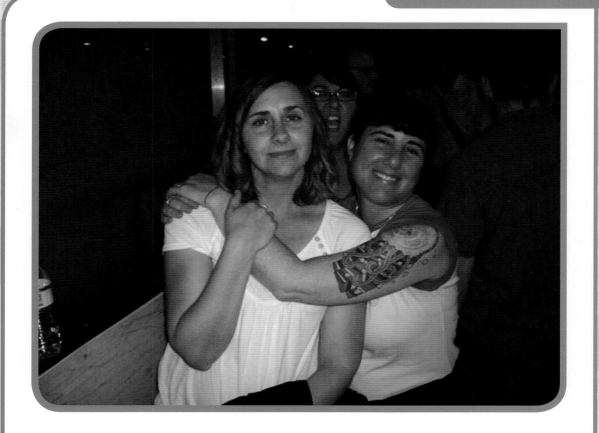

"Why don't you love me too? Whyyyyy?"

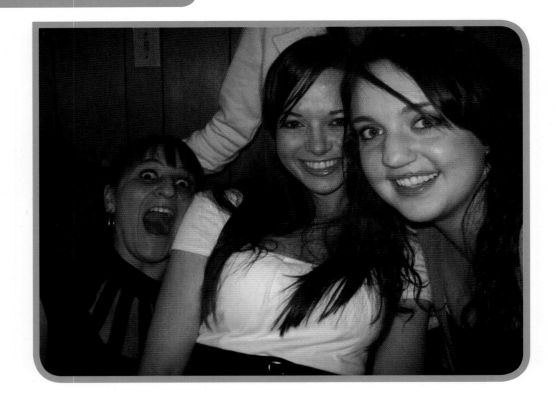

LOOKS LIKE SHE MIGHT HAVE A CAVITY.
BETTER GET THAT CHECKED OUT.

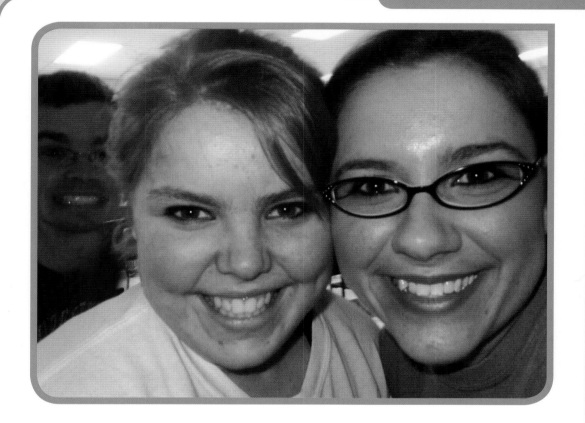

KEEP THOSE HANDS WHERE WE CAN SEE THEM, BUDDY.

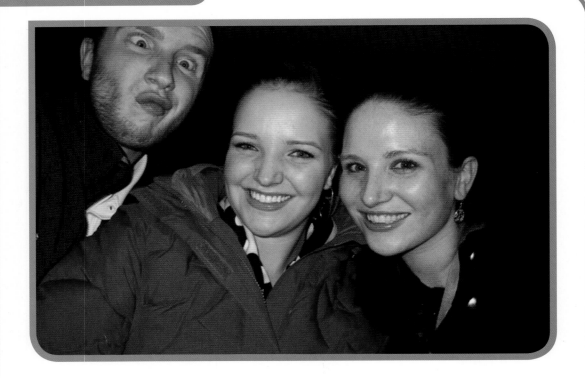

IT SURE WAS NICE OF MAUREEN AND HER FRIEND
TO LET THEIR "SPECIAL" FRIEND INTO THEIR PICTURE.
HE DOESN'T GET OUT MUCH, YOU KNOW, SINCE THE ACCIDENT.

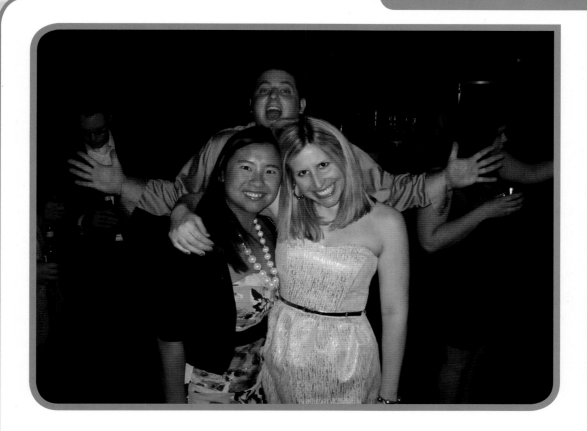

HE'D NEVER SAY SO, BUT THESE GIRLS
ARE THE WIND BENEATH BOB'S WINGS.

party bombs

What do you get when you cross groups of fun people, cameras, and lots and lots of delicious alcohol? Prime photobombing material, that's what!

This chapter offers a glimpse into the social lives of some of our funniest *Oddee* fans. You will be transported back to a time when Mom and Dad leaving for the weekend meant that all of your high school buddies learned how to syphon vodka from their parents' liquor cabinets and replace it with water, and you subsequently learned how to get vomit stains out of Berber carpet. You'll recall what it was like to be young, single, and incredibly cruel to your liver on a nightly basis. And if you're anything like us, you'll remember what it felt like the day *after* the party, when you woke up with a pounding head and a mouth that tasted like it had been used as a kitty litter box while you slept. Frankly, that may have been just the case, judging by some of these pictures.

Good times! If you're ready to relive those days of youthful debauchery and excess, start pounding shots and we'll catch you on the flip side. We'll be waiting for you at the end of this chapter with a fistful of ibuprofen and a lot of water, because we care about you (and your hangover).

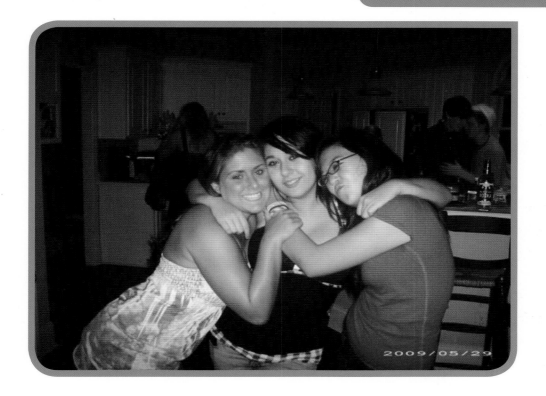

2009/05/29

WELCOME TO EVERY HIGH SCHOOL PARTY EVER.
OUR FAVORITE PART IS THE "I LOVE YOU, MAN!"
MOMENT BETWEEN THE GUYS IN THE BACK.

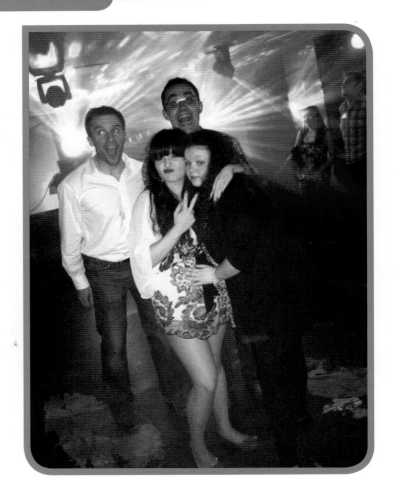

OMG LOOK! REAL GIRLS!

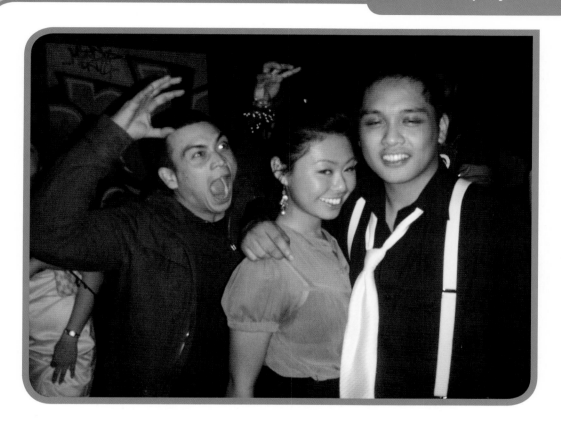

SOMEONE FORGOT HIS MEDICATION...BUT THE GUY
ON THE RIGHT MIGHT HAVE TAKEN A DOUBLE DOSE.

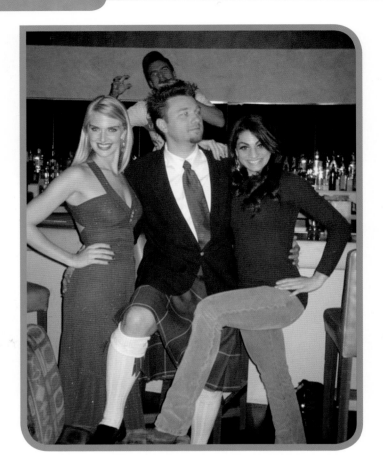

ONCE YOU STOP TRYING TO SNEAK A PEEK UP
HIS KILT YOU MIGHT NOTICE THE PHOTOBOMBER.
MAYBE NOT, THOUGH...THOSE GIRLS ARE PRETTY HOT.

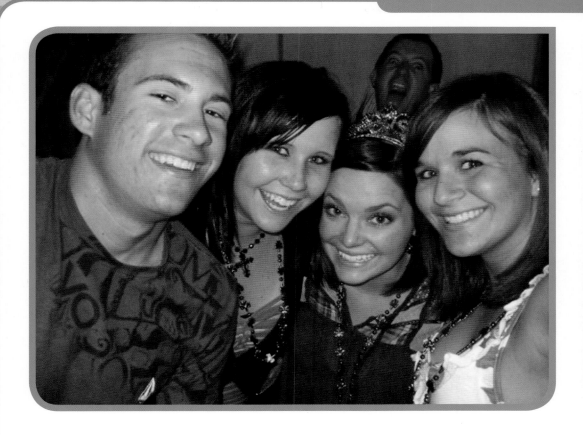

JUST GIVE HIM THE LUCKY CHARMS
AND NO ONE GETS HURT!

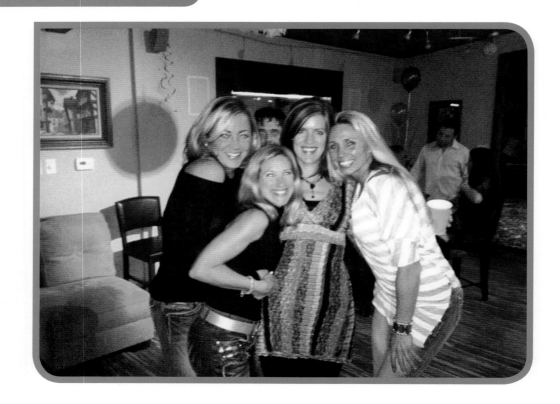

"THAT GUY STANDING CREEPILY IN THE BACKGROUND REALLY IMPROVED THE PHOTO," SAID ABSOLUTELY NO ONE.

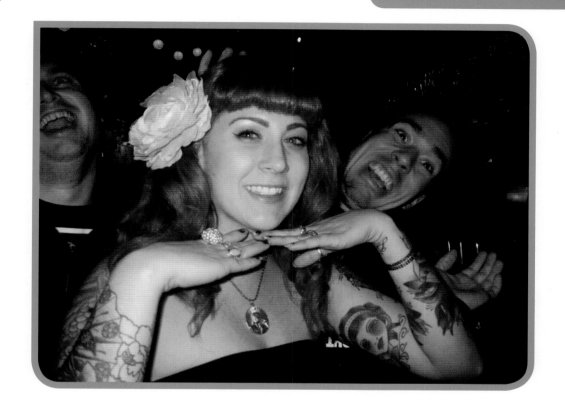

TWEEDLE DUM AND TWEEDLE DUMMER.

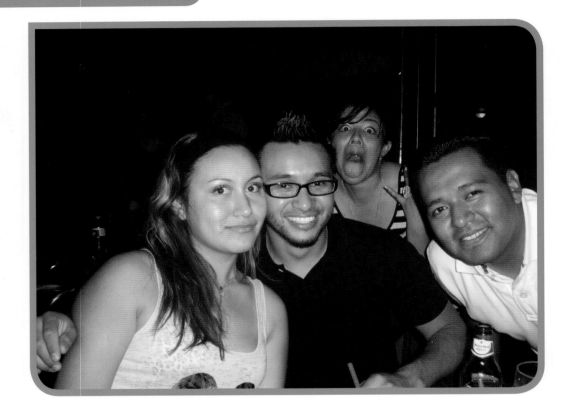

"WHO WANTS TO SEE MY UVULA?"

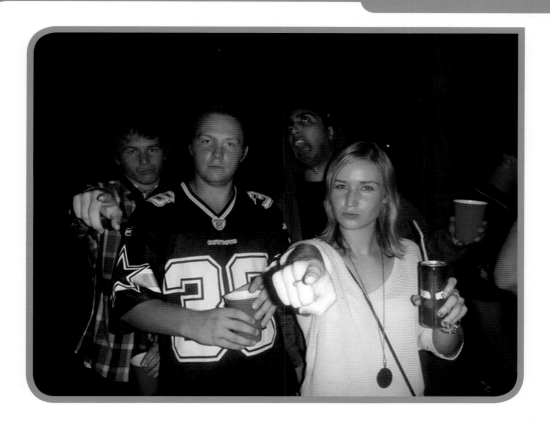

THREE OUT OF FOUR COWBOYS FANS
THINK YOU'RE AWESOME.

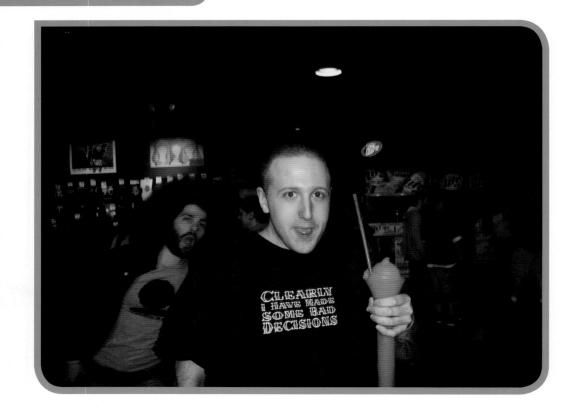

WHEN THE PHOTOBOMBER WITH THE
'FRO LOOKS COOLER THAN YOU DO, IT'S TIME
TO REEVALUATE YOUR (BAD) DECISIONS.

NO ONE HAS BEEN THIS EXCITED
TO SEE SLASH AT A PARTY SINCE 1996.

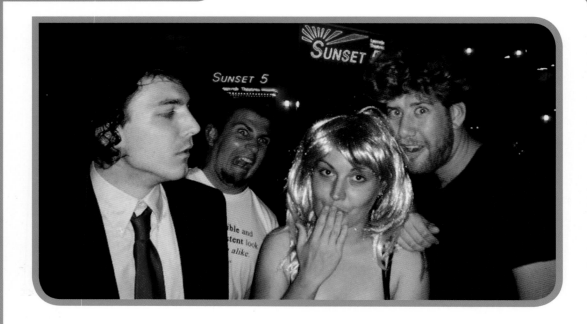

"I CAN'T BELIEVE YOU GUYS HAD
CRAZY WIG NIGHT AND DIDN'T INVITE ME!"

tv bombs

In today's day and age, the television is almost always on, even if no one is paying attention to it. Sometimes it's just on for background noise…and sometimes it provides the perfect backdrop for your funniest photobombs! How else could average (read: non-famous) people get photobombed by Shrek or Morgan Freeman while just hanging out in their living rooms?

Not all of the bombs in this chapter are on the television, either. Read on to see how just about any inanimate object can photobomb an unsuspecting victim when they least expect it!

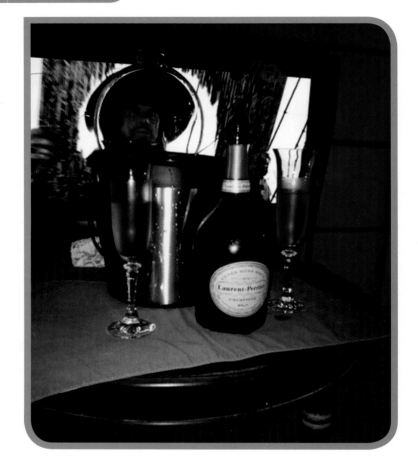

"ARR, THERE'D BETTER BE STRAWBERRIES TO GO
WITH THIS CHAMPAGNE, MATEY, OR YE'LL
BE WALKING THE PLANK TONIGHT!"

HE SEEMS PRETTY CALM, CONSIDERING
HE'S ABOUT TO BE TERMINATED.

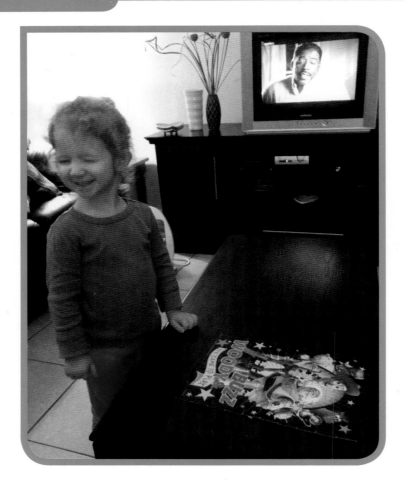

ERNIE HUDSON THINKS YOU DID
A BANG-UP JOB ON THAT PUZZLE, KID!

MORGAN FREEMAN REALLY *IS* IN EVERYTHING!

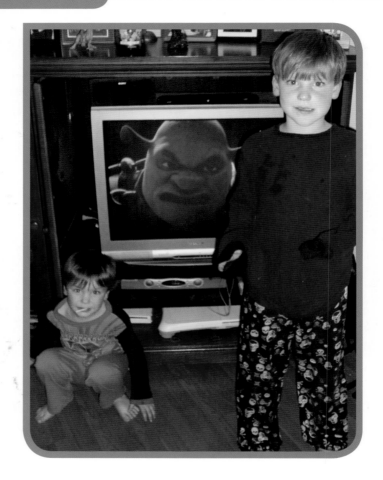

DON'T MAKE SHREK ANGRY, BOYS.
YOU WOULDN'T LIKE HIM WHEN HE'S ANGRY.

"I'M RICK JAMES, I'M SUPPOSED TO LOOK CRAZY!
WHAT'S YOUR EXCUSE, RAINBOW BRITE?"

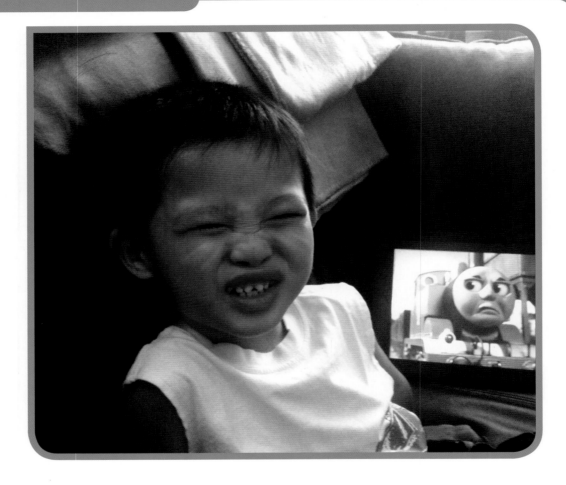

THOMAS THE TANK ENGINE IS NOT
SO SURE ABOUT THIS GUY.

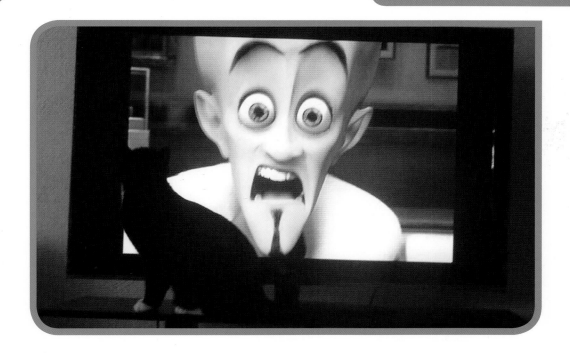

"YOU MEAN YOU POOP IN A BOX THEN
THE HUMANS CLEAN IT UP?!
YOU'VE GOT TO BE KIDDING ME!"

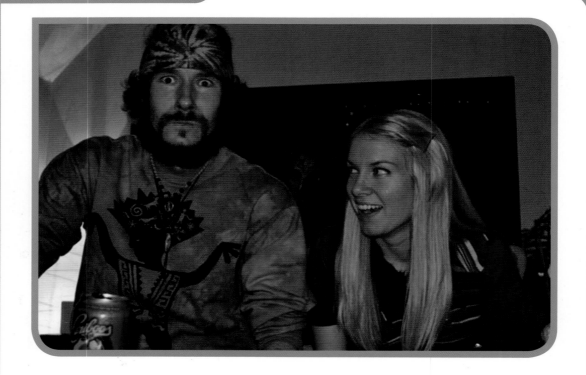

WHOEVER SMELT IT, DEALT IT.

wedding bombs

We love weddings! These celebrations of love and devotion are always happy occasions, and since they're one of the few life events that professional photographers are almost always in attendance at, we had no shortage of wedding photobombs to choose from for this chapter.

The guests who did the bombing in these photos all have one thing in common; they had the chicken marsala at the reception and double-dipped their pretzels in the chocolate fountain when they thought no one was looking. Aside from that, each photo is uniquely amusing in its own way. We've got photobombing brides, photobombing kids, and what we suspect is a photobombing wedding crasher, though we can't back that up.

If there's a better way to commemorate eternal love than by getting drunk with family and friends and sticking your face into fancy pictures, we haven't yet discovered it! Congrats and mazel tov to all of the newlyweds, and thanks for sharing your funniest memories with us. We promise to only make fun of them a little bit.

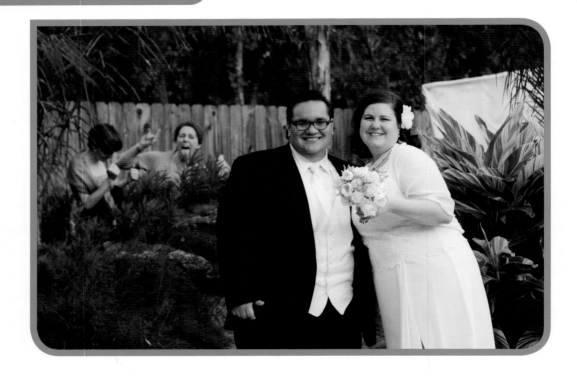

"THIS WEDDING ROCKS!"

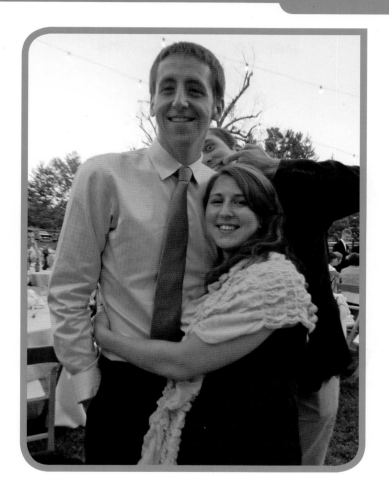

"DO I HAVE SOMETHING IN MY TEETH?
RIGHT HERE, TOWARD THE BACK?"

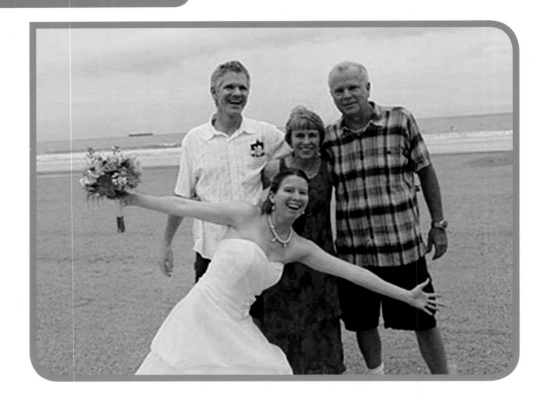

BRIDE BOMB!

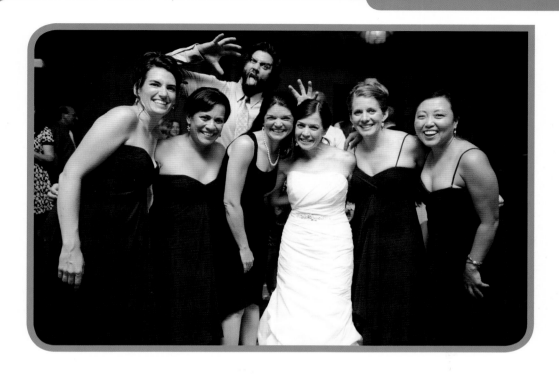

ARE WE SURE THIS GUY WAS INVITED?

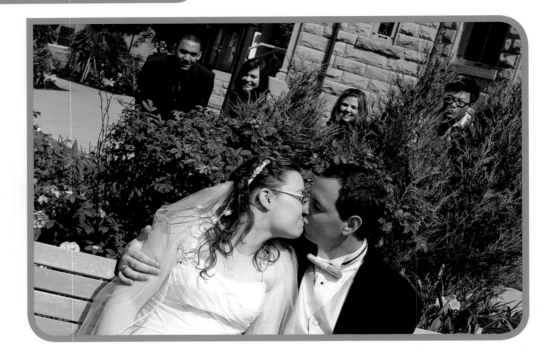

JUST BE GLAD THIS PICTURE WASN'T TAKEN
ON THE WEDDING NIGHT. AWKWARD!

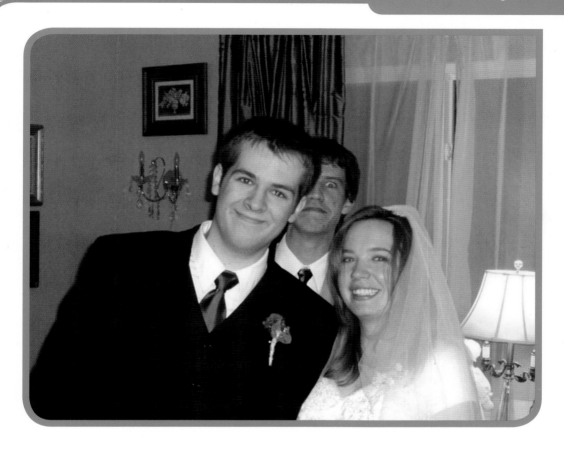

NOT PICTURED: THE ANGEL ON HIS OTHER SHOULDER.

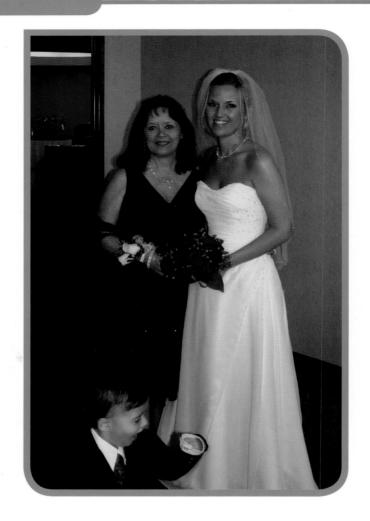

HEY KID, COULD YOU HAND US THAT—OH, NEVER MIND. SORRY.

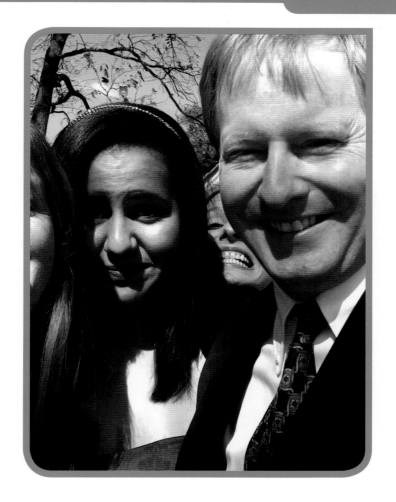

HERE COMES THE BRIDE, ALL PEARLY AND WHITE...

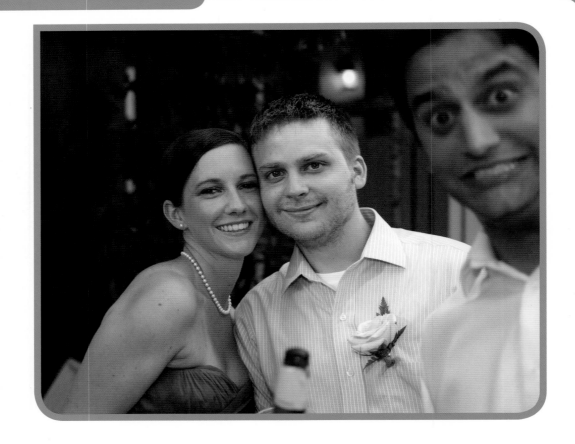

"MIND IF I STEP IN?"

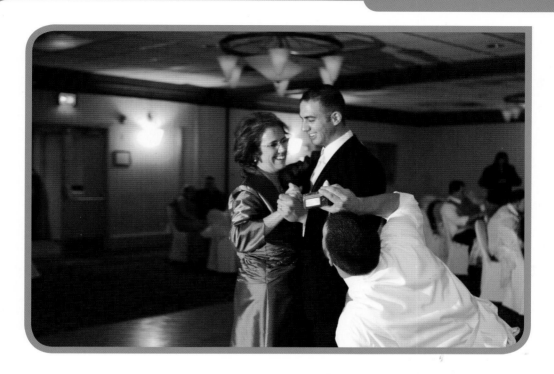

WE'RE SURE THIS GUY'S "UP-THE-NOSE" SHOT
IS BETTER THAN THE SHOT THAT THE
PROFESSIONAL PHOTOGRAPHER WAS TAKING.

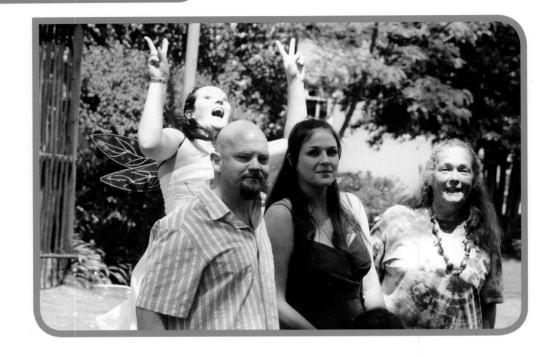

AH YES, THE "FLYING BUNNY EARS" BOMB. A CLASSIC!

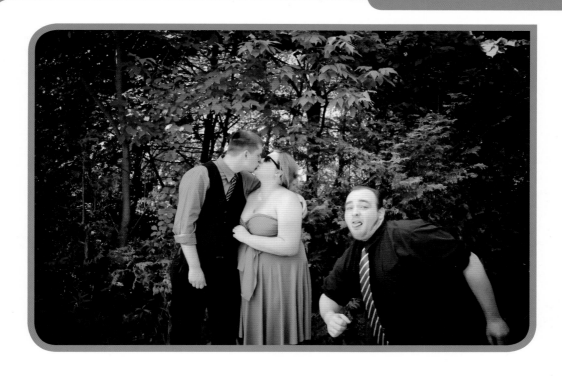

"FRAME THIS, SUCKERS!"

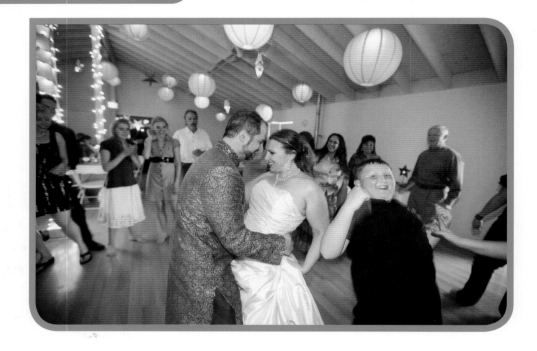

HIS MOM IS ABOUT TO SNATCH HIM
OFF THE DANCE FLOOR. WINNING!

kid bombs

They're small, they're cute, and they're annoying as hell sometimes. What? It's true and you know it. We are sure that we can't be the only parents who have stuffed our little darlings into sweater vests and shiny shoes for a family portrait, only to have them make a horrible face or ambush the camera the second we take our eyes off of them. It's just kid nature; it's what they do.

Because sitting still and posing prettily for pictures isn't their strong suit, children tend to make excellent photobombers. Check out the adorable little ~~brats~~ darlings in this chapter as they subtly (or not so subtly) steal the show in every picture they're in!

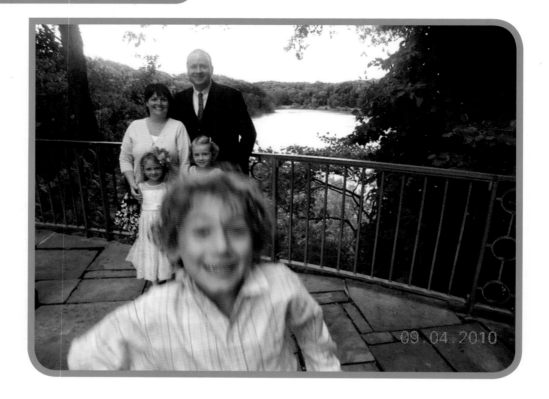

"I ATE A LOT OF SUGAR BEFORE THIS PICTURE.
SUGAR IS AWESOME!!!"

THIS CHILD PUTS THE "MAGIC" IN MAGIC MOUNTAIN.

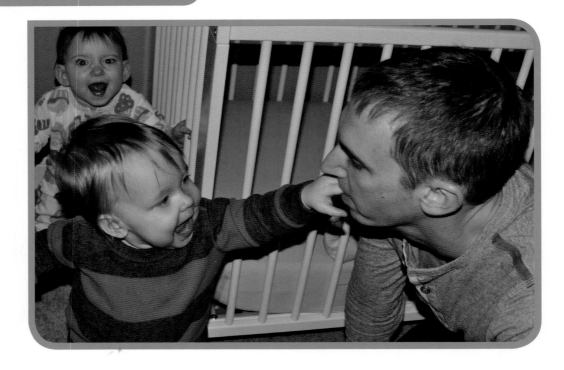

THANKFULLY, ONLY TIMMY'S SISTER AND
THE DOG KNEW WHERE THAT HAND HAD BEEN.

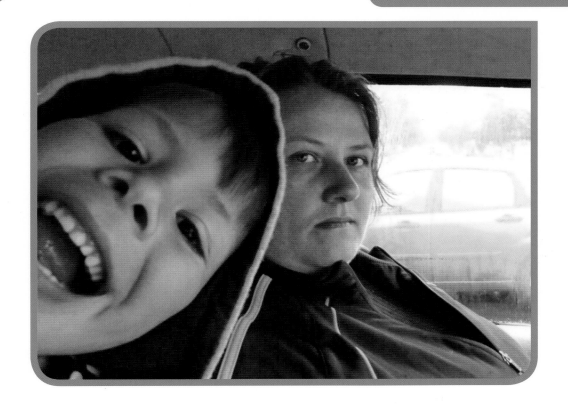

"HEY MOM, GUESS HOW I GOT MY NOSTRILS SO CLEAN?
HINT: I USED MY FINGER."

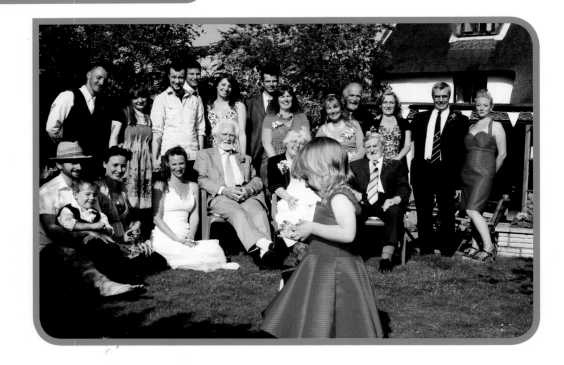

DOWN IN FRONT, KID! GRANDPA LOOKS LIKE
HE'S MELTING IN THE SUN BACK THERE.

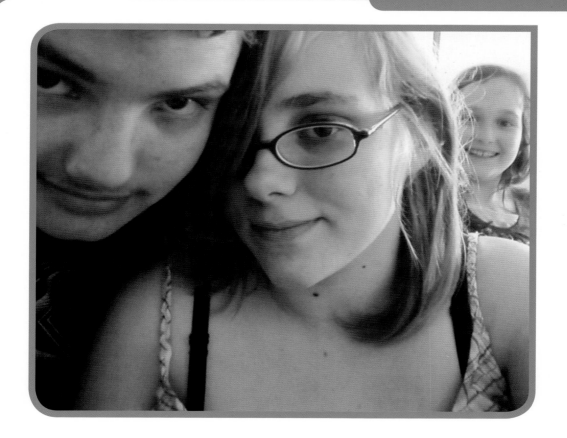

TYPICAL LITTLE SISTER, ALWAYS HORNING IN ON THE ACTION.

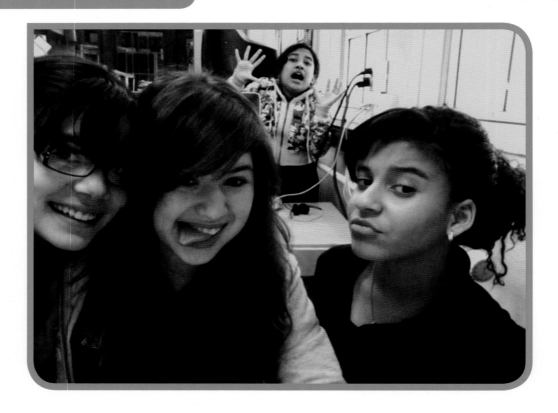

THE LAST PHOTO TAKEN OF MARIA BEFORE
THE FREAK TOASTER ACCIDENT.

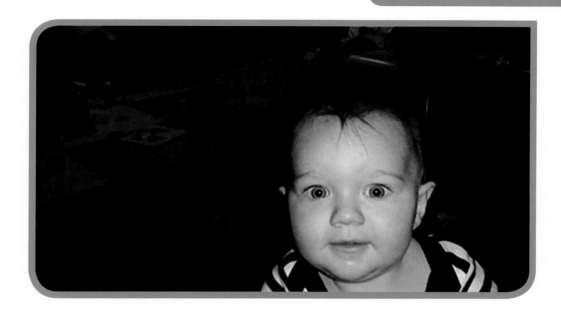

CAT, INTERRUPTED.

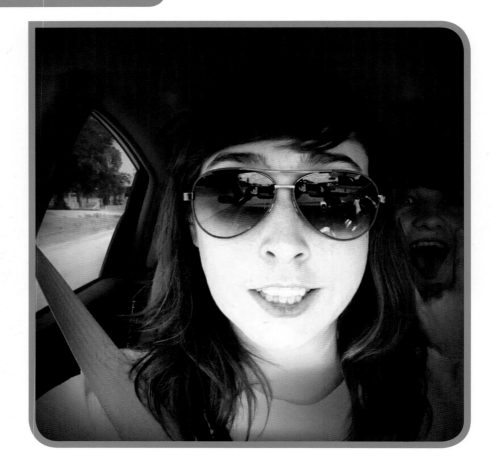

ONE KICK-ASS PROFILE PICTURE, COMIN' UP!

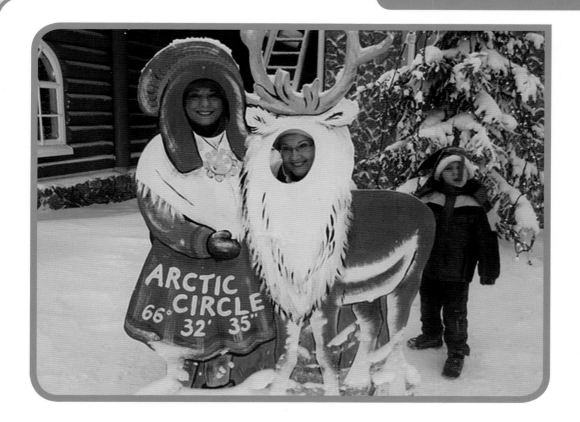

SORRY KID, BUT THOSE BROWN THINGS YOU JUST ATE
OFF THE GROUND WEREN'T HERSHEY'S KISSES.

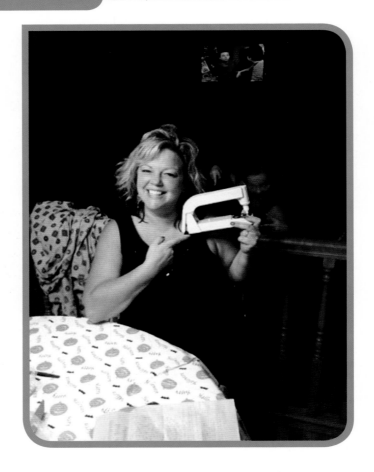

THESE TWO ARE GOING TO BEDAZZLE
THE *SHIT OUT* OF SOME THINGS LATER.

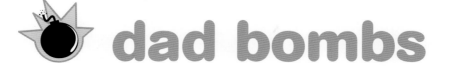

dad bombs

Once you become a father, you give up a lot of things. Things like spending Sundays getting drunk on Pabst while watching football in your buddy's basement, for instance, and having a thirty-two-inch waist. Things like having too much pride to allow your five-year-old daughter to paint your toenails the perfect shade of OPI "Cabana Banana." One thing that fatherhood will never rob you of, however, is your right to crash your kids' pictures before they are even born until they are old enough to vote (and beyond)!

Photobombing dads are fun dads, and it's no surprise that *Oddee*'s readers are a fun bunch. Here are a few fathers who have earned both that kick-butt popsicle-stick picture frame you made him in third grade AND a place in our photobombing hall of fame.

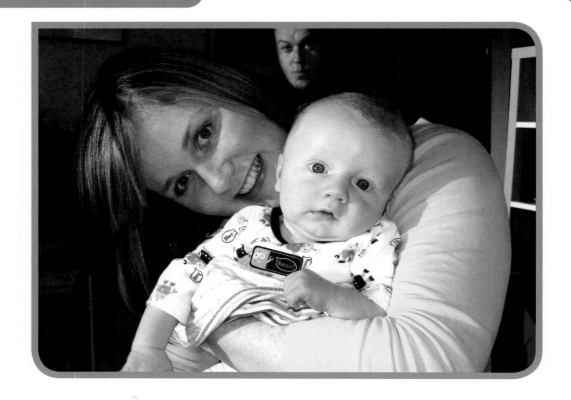

BOND. DAD BOND.

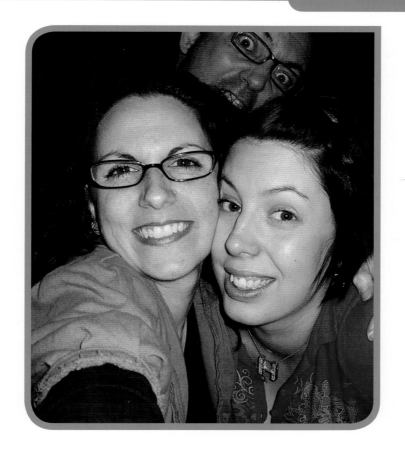

LIKE MOST TEENAGERS, HEATHER FELT LIKE SHE HAD THE WEIRDEST PARENTS IN THE WORLD. WHAT SHE DIDN'T REALIZE WAS THAT SHE WAS EXACTLY RIGHT.

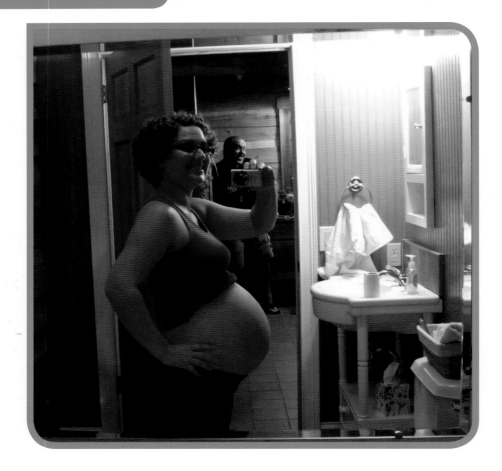

BELLY BOMB!

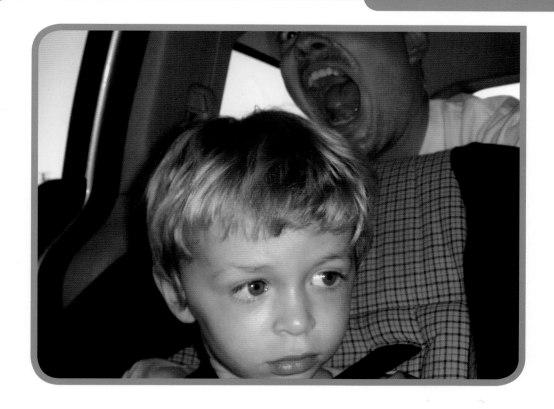

YOU KNOW HOW IN *LOONEY TUNES*, SYLVESTER THE CAT ALWAYS SEES TWEETY AS A BIG, TASTY DRUMSTICK? THIS IS KIND OF LIKE THAT.

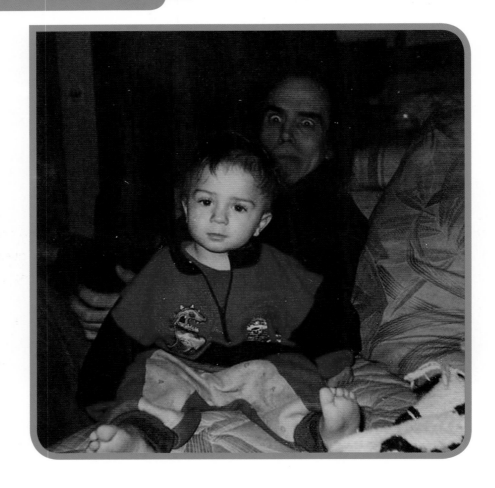

"WHO IS THIS KID AND WHY IS HE ON MY COUCH?"

 # beach bombs

The sun, the sand, the Speedos! Some people have no shame once they set foot on the sandy shores of their favorite beach, which is why we had so many great shots to choose from for this chapter. Honestly, we haven't seen this many sketchy people making questionable bathing suit choices since we accidentally changed the TV channel to *Jersey Shore* that one time.

One thing is for sure—the sun does addle your brain if you lie out long enough, which is the only way we could ever explain some of the pictures you're about to see. We've got toothless old men ogling tweens, couples canoodling in broad daylight, and one little girl whose encounter with a bevy of Lycra-clad crotch bulges may have helped her future therapist buy that vacation house in Cabo that he's always wanted.

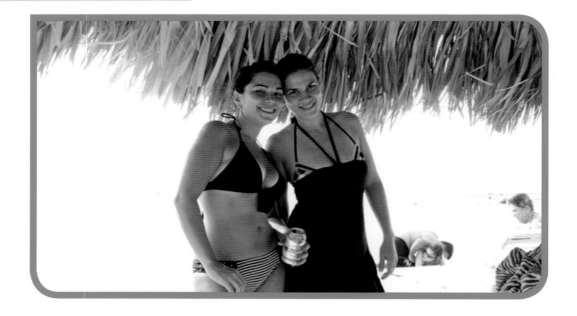

GET A ROOM!

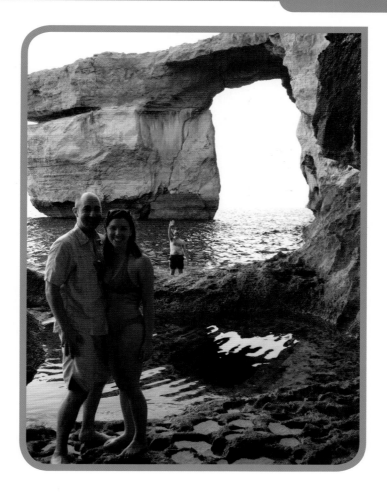

AND WITH THAT, CLYDE SLIPPED QUIETLY BACK
INTO THE SEA AND REJOINED THE MERPEOPLE.

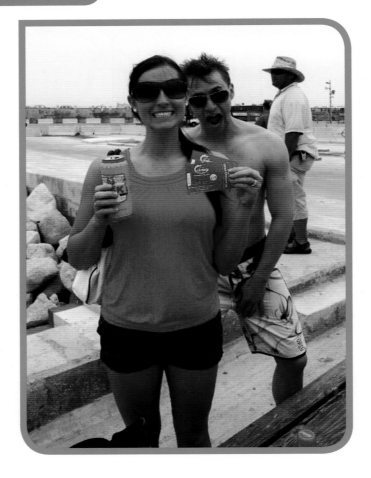

SHE'S GOT TWO TICKETS TO PARADISE...AND
NEITHER ONE OF THESE GUYS IS INVITED.

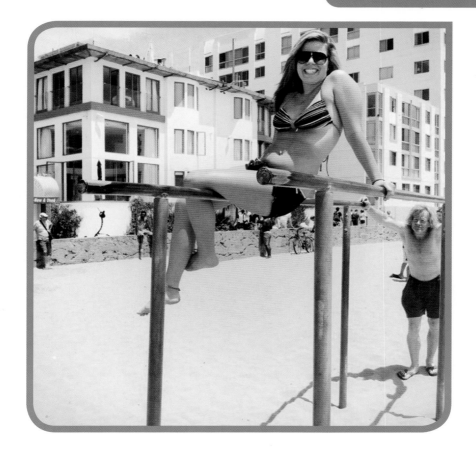

WE'RE NOT SURE IF HE IS WAITING
FOR HIS TURN ON THE PARALLEL BARS
OR IF HE'S JUST ADMIRING THE VIEW.

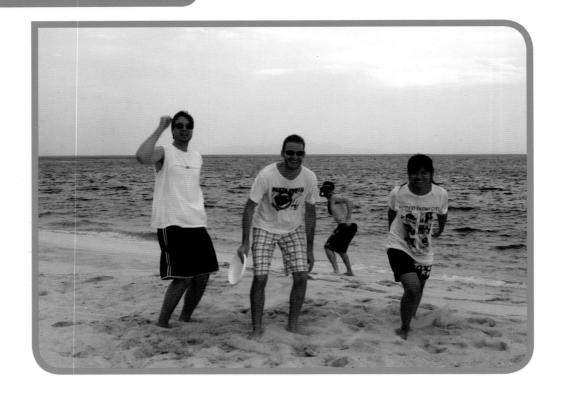

THIS IS DEFINITELY THE "BEFORE" SHOT.
BE GLAD WE DIDN'T SHOW YOU THE "AFTER."

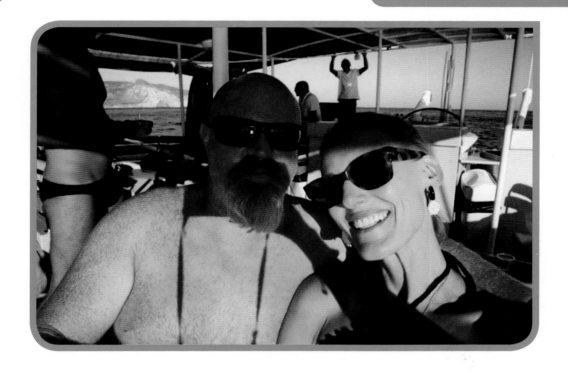

Banana Hammock, 9 o'clock.

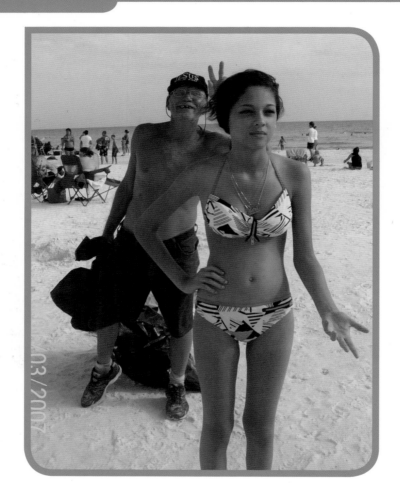

"DAAAAAD! CAN'T YOU COLLECT YOUR CANS OVER *THERE?*"

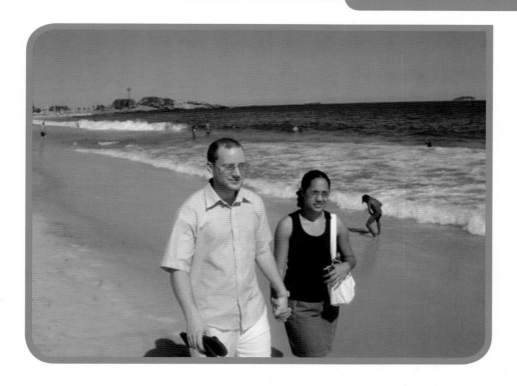

Beware of sand crabs.

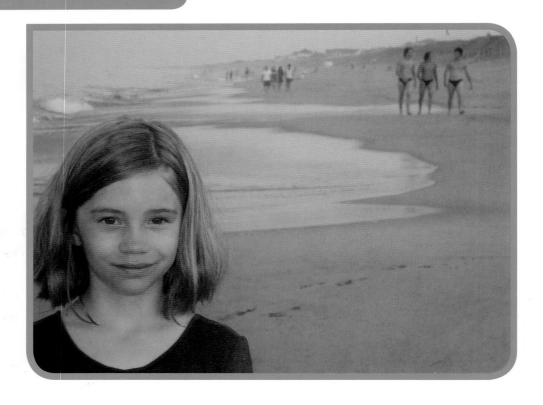

"WE'D BETTER HURRY IF WE WANT TO MAKE
THE OPENING CEREMONY OF THE SPEEDO CONVENTION!"

tmi bombs

We can be as raunchy as the next guys, but there are some things that are simply too much information (TMI)! The crotch grabbers, wall-pee-ers, and bum-lookers in this chapter all fall solidly into the category of *Things We Can Never Unsee*, which is why we're showing them to you, naturally!

This chapter isn't for the faint of heart. It's not that you'll be scarred for life by the relatively tame photos we've selected for your TMI-loving pleasure. It's just that you may never be able to see a group photo again without having the sudden urge to drop trou' and bomb that picture with your very own full moon! Don't say we didn't warn you, and don't come crying to us when your lawyer starts using words like "lawsuit" or "indecent exposure."

Deal? Deal. Now enjoy seeing too much information from a bunch of random strangers. We certainly did.

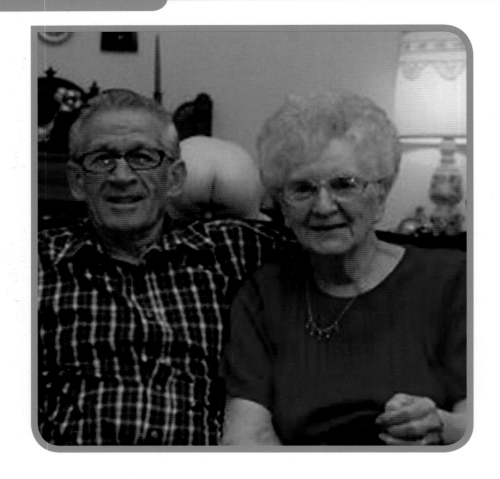

MOON OVER MY GRAMMY.

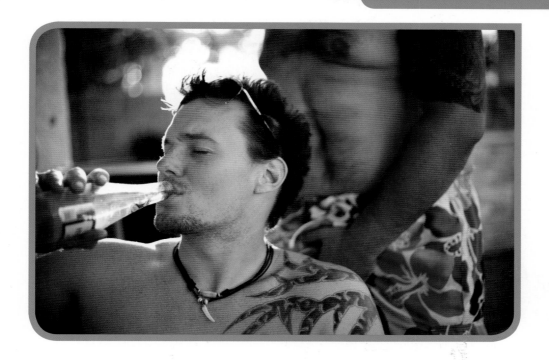

JUST A COUPLE OF BROS ENJOYING A COLD BREWSKI.
NOTHING ODD ABOUT THAT.

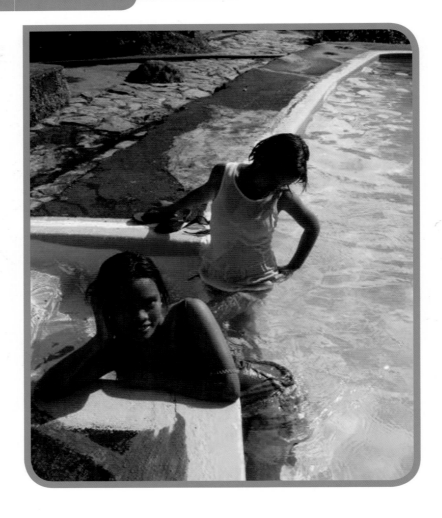

TAKE A PICTURE, IT LASTS LONGER. OH, WAIT...

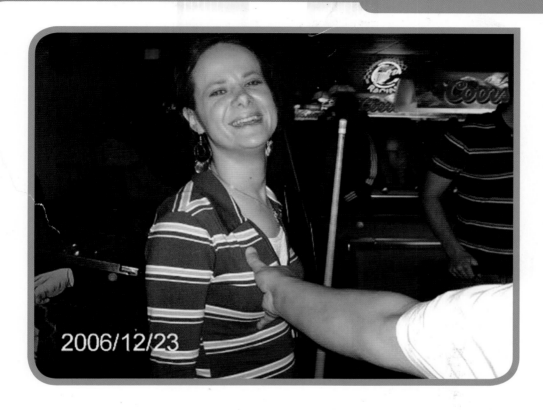

HAND BOMB!

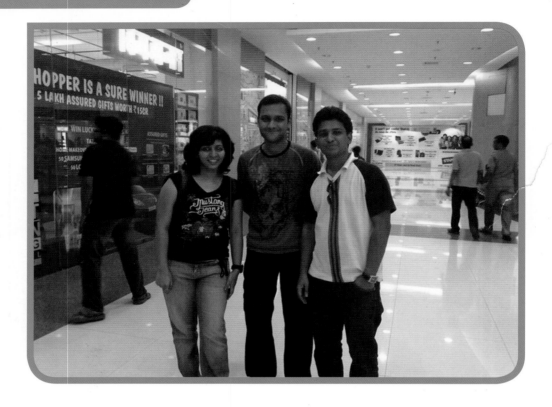

THAT GUY IS REALLY EXCITED ABOUT THE SALE.
REALLY EXCITED.

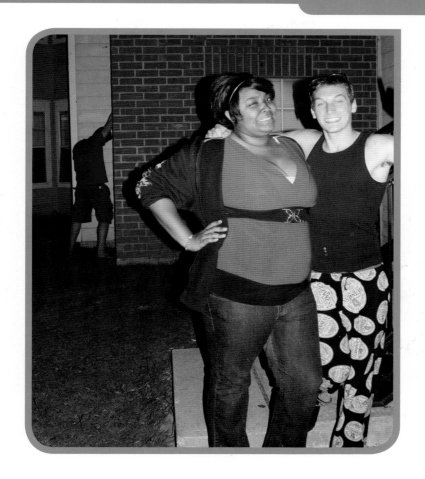

EVER BEEN SO DRUNK THAT YOU NEEDED A WALL
TO KEEP YOU UPRIGHT? YEAH, NEITHER HAS HE.

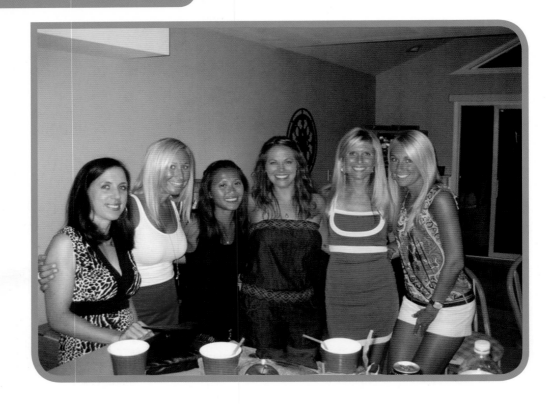

RICK COULD ALWAYS BE COUNTED ON
TO PROVIDE THE "FULL MOON" FOR TAWNY'S
MONTHLY APRES-TANNING PARTY.

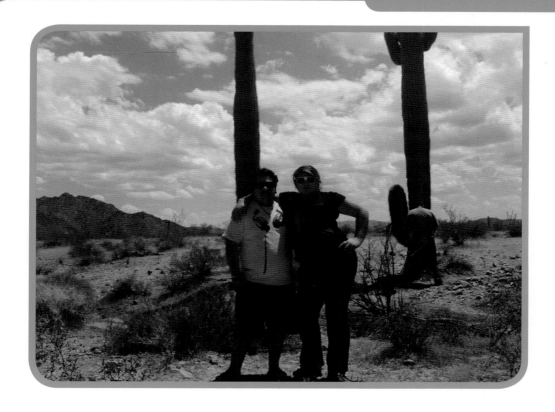

SECONDS LATER, JORGE LEARNED WHY IT'S NOT A GOOD IDEA TO STAND TOO CLOSE TO A CACTUS WHILE RELIEVING ONESELF.

 # peek-a-bombs

Peek-a-bombs are perhaps our favorite kind of photobomb, and not just because we came up with a cutesy-poo name for them. We love them because they're so subtle and so unexpected; you can look at a picture ten times and never notice the photobomber, but once you see them, you can never NOT see them again!

These photobombs seem like normal pictures until you notice those tiny little faces squished in where you least expect them. They're the little heads popping up over your shoulder or in your fruity cocktail; they're the extra eyes or mouth that appear between two faces, seemingly out of nowhere. They're surprising, they're sometimes hard to spot, and above all, they crack us up! Ready to test your keen observation skills and spot the peek-a-bombers? Go!

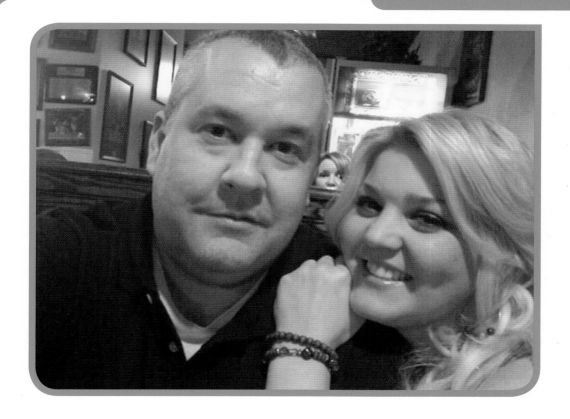

NOTHING WRONG WITH A LITTLE HEAD.

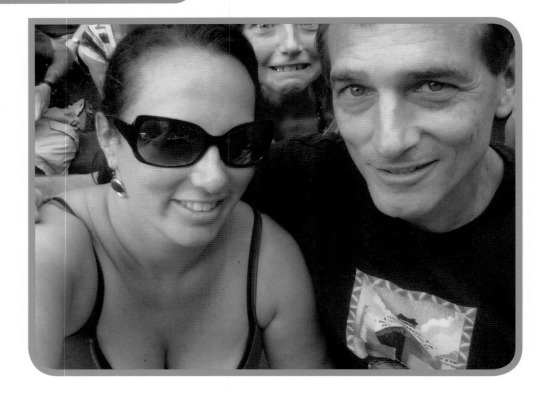

LET MORGAN OFF THE BOAT! SHE CLEARLY HAS TO PEE.

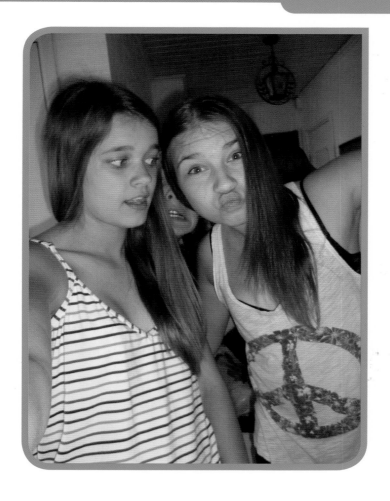

"I AM NOT AN ANIMAL!"

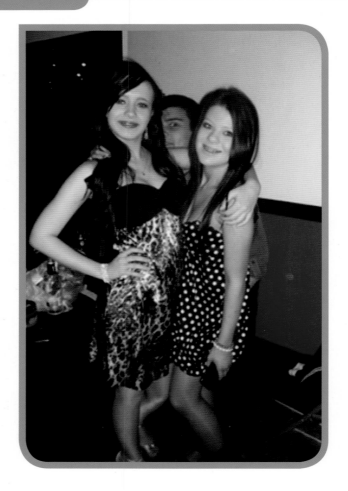

HE'S GIVING YOU THE EYE. (JUST THE ONE.)

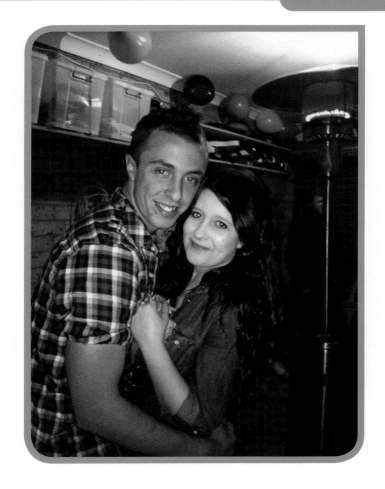

NO, IT'S NOT THE GUY IN THE BLACK COAT. LOOK CLOSER.

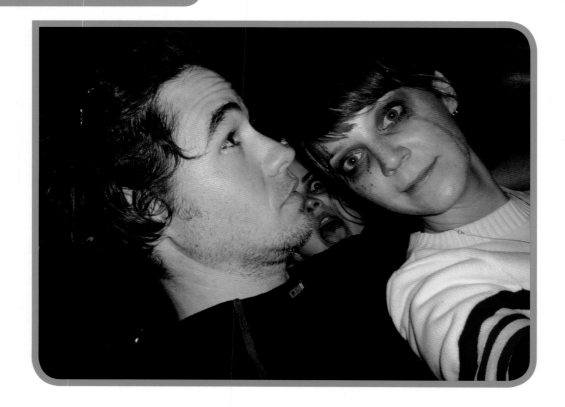

ZOMBIE GIRLFRIENDS PREFER GUYS WITH BIG...BRAINS.

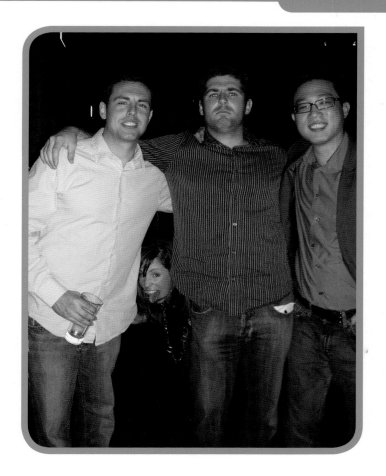

HONEY, AT LEAST WAIT TILL WE'RE DONE TAKING PICTURES!

 # costume bombs

Dressing up is not just for kids; it's not even just for Halloween! As you'll see in this chapter, even adults like to don some crazy wigs and makeup now and then, and something about getting dressed up makes for some pretty hilarious photobombs.

We've got a great assortment of people dressed as kitties, bunnies, ship captains, soldiers, and not just one but *two* appearances by the Joker at Comic-Con. So glue on your false eyelashes, adjust your wigs, and add some double-sided tape to that low-cut pleather halter top, because you're in for a whole lot of costume party fun and you definitely need to blend in with this crowd!

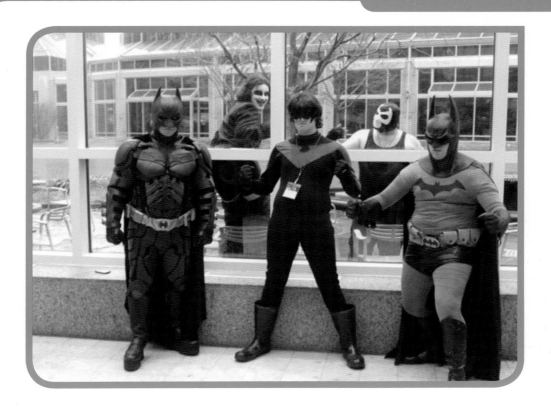

NO ONE ESCAPES A JOKER BOMB!
NOT EVEN YOU, FAT BATMAN.

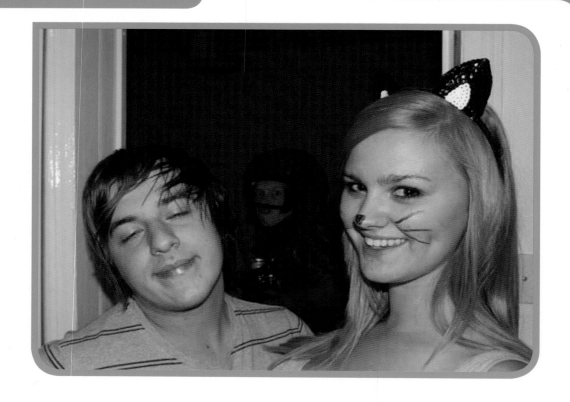

DICK DASTARDLY IS CLEARLY APPALLED
BY YOUR LACK OF PROPER COSTUME ATTIRE.

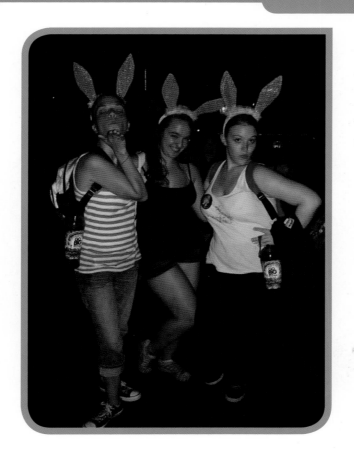

THOSE PLAYBOY MODELS KEEP GETTING
YOUNGER AND YOUNGER!

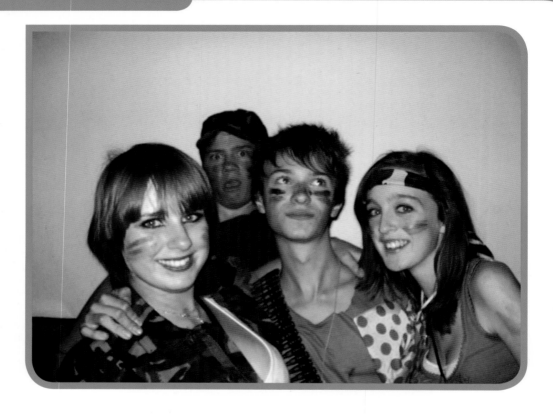

THOSE UNIFORMS ARE NOT REGULATION, SOLDIERS.

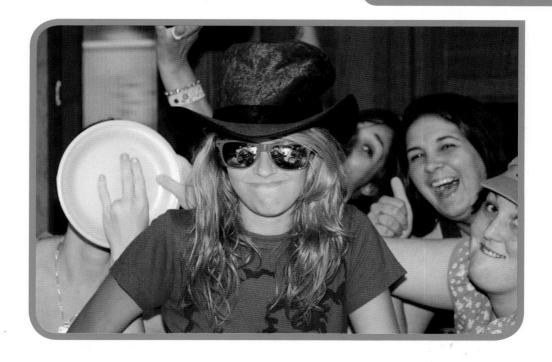

MELISSA OFTEN FELT LIKE EVERYONE AT THE PARTY
WAS TALKING ABOUT HER BEHIND HER BACK,
BUT SHE WAS PROBABLY JUST BEING PARANOID.

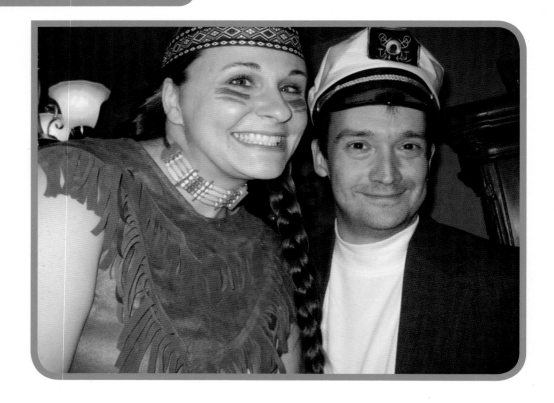

EVEN MARTHA'S MOM COULD NOT GET BETWEEN
HER AND THE CAPTAIN.

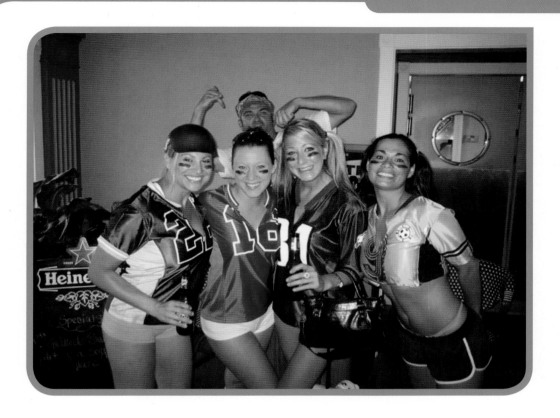

THIS IS WHY HOOTERS ONLY HIRES MEN
AS KITCHEN STAFF, NOT WAITSTAFF.

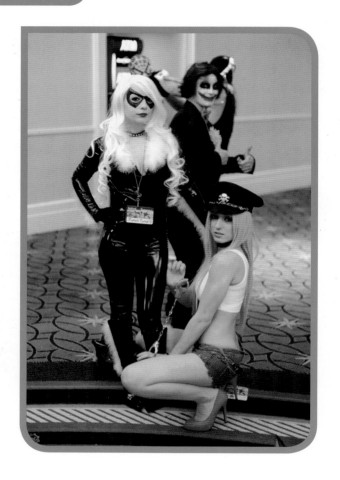

WHAT DO WE HAVE TO DO TO GET ARRESTED BY THIS COP?

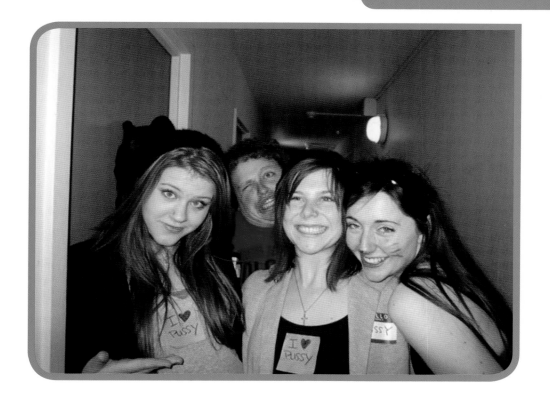

STROKES ARE NO LAUGHING MATTER, GIRLS.

wtf bombs

What can we say? We received a lot of pictures from all over the world and from people from all walks of life, so it's only natural that we got a few photobombs that made us say, "What the f#@k are we looking at?!" These are those photobombs.

These are the zaniest of the zany; the weirdest of the weird; the WTF-iest of the WTF. We've looked at these pictures countless times and still don't know what to make of some of them. Others are simply people making the strangest, most unnatural faces you've ever seen, so we thought those qualified as WTF too. No matter how you look at it, this chapter is a noggin-scratcher to the ninth degree, which makes it one of our favorites in the whole book. Hey, what do you expect? We're *Oddee*; we like Odd stuff!

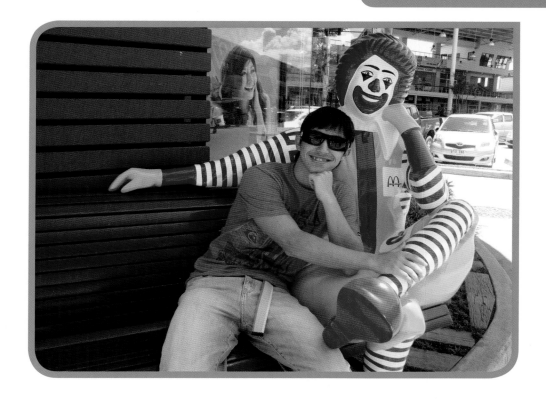

WE HAVEN'T SEEN THE "HAND-UNDER-CHIN" POSE
THIS MUCH SINCE OUR LAST TRIP TO GLAMOUR SHOTS!

DON'T WORRY, BABY REGINA. THERE'S NOT A CREEPY
GREEN THING STARING AT YOU RIGHT NOW AT ALL.
NO WAY! SWEARSIES.

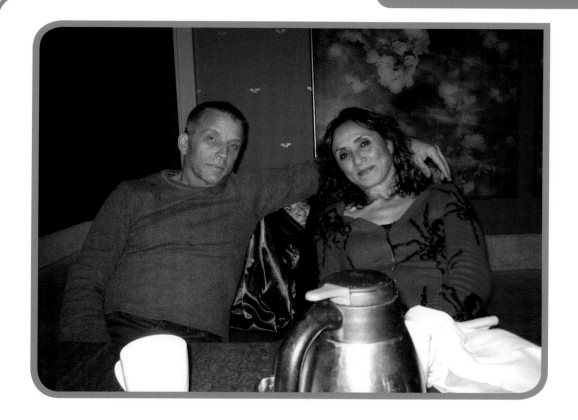

20 PERCENT PEEK-A-BOMB, 80 PERCENT WTF BOMB.

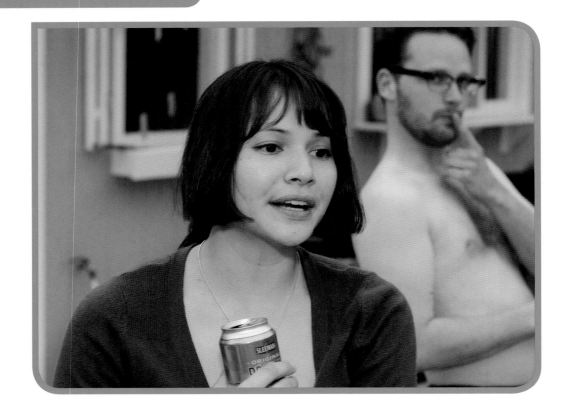

OOH, SAUCY!

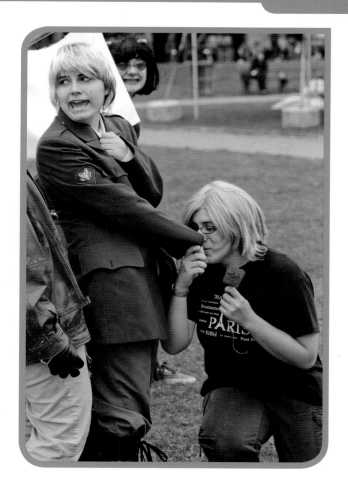

DON'T ASK US; WE DON'T HAVE ANY CLUE
WHAT IS HAPPENING HERE EITHER.

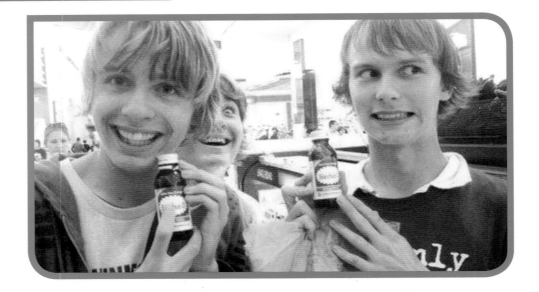

PEP PILLS MAKE THEM PEPPY! WANT SOME?

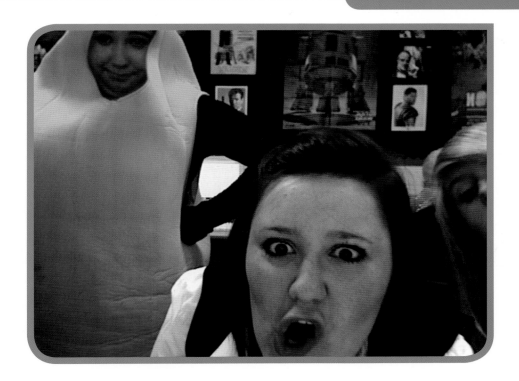

DISGRUNTLED BANANA BOMB!

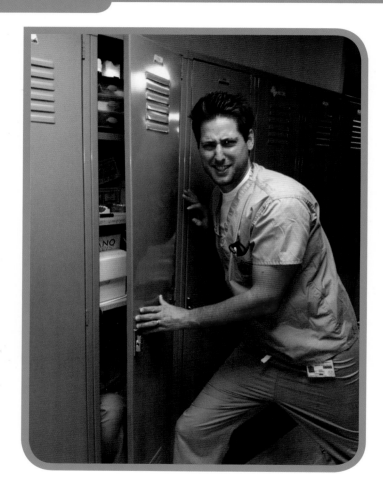

WE MUST HAVE MISSED THIS EPISODE OF SCRUBS.

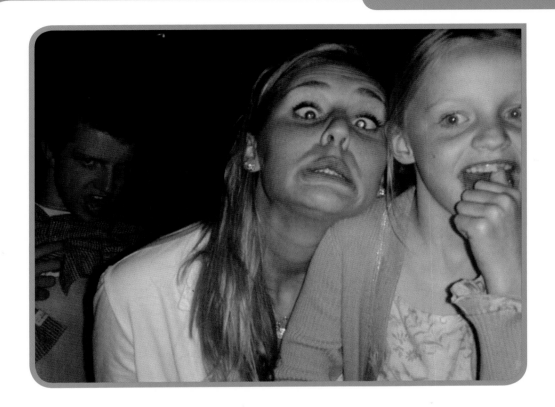

GOOD LUCK WITH THOSE PARENTS, KIDDO.

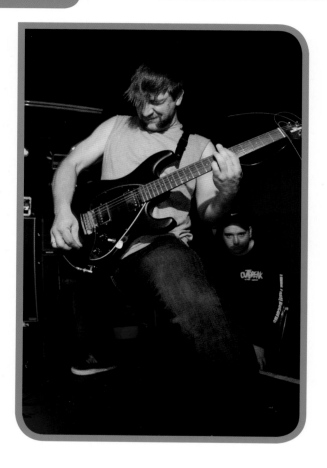

THOSE WHO CANNOT DO...STAND QUIETLY
AND CREEPILY IN THE BACKGROUND.

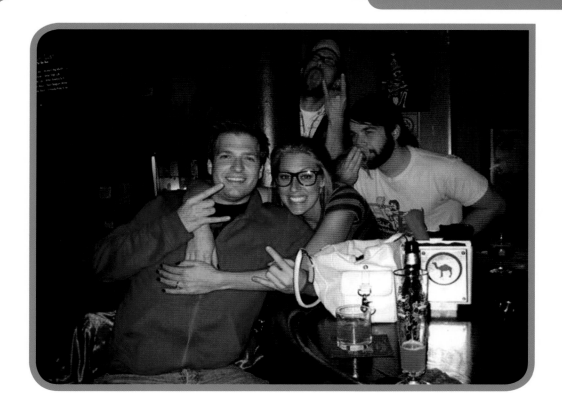

THE NEXT MORNING, AFTER DISCOVERING THIS PHOTO
ON HER CAMERA, SARAH DECIDED TO CUT HER HAIR
REALLY, REALLY SHORT.

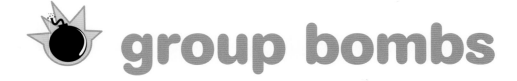

group bombs

Anyone who has ever tried to take a picture of a group of people can tell you that it's no picnic. You've got to get them all dressed and presentable-looking, get everyone assembled in just the right way, and then try to hold their attention by dangling shiny things in front of them and demanding that they say "Cheese" over and over again. Or maybe that's just our families?

The real challenge is to somehow get everyone in the group to have a decent expression on their faces at the same time, which is especially hard when you have relatives as ugly as we do. Once you've done all the work to get everyone ready, it's the photobomber's time to shine, and suddenly your photo goes from "meh" to "marvelous" in two seconds flat!

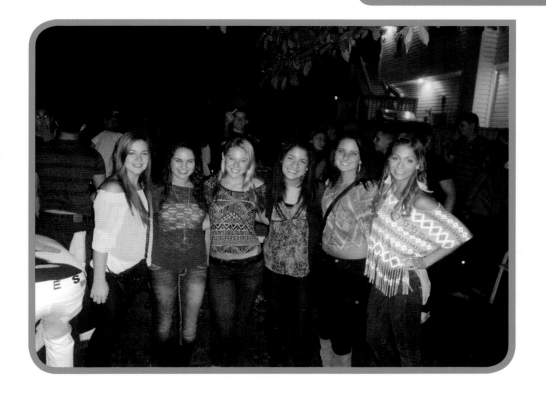

WE KNOW ONE DUDE WHO JUST GOT UNINVITED
TO THE NAKED HOT TUB AFTER-PARTY.

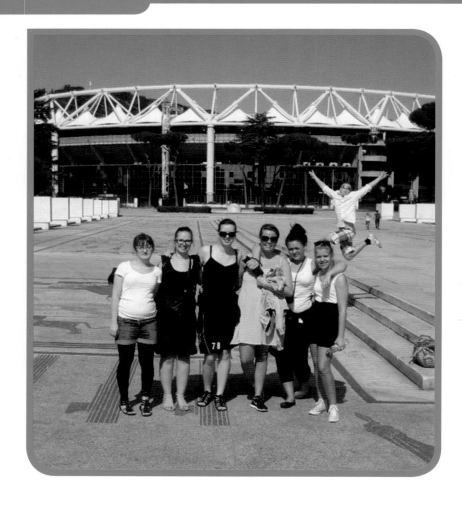

FLY FREE, PLAID SHORTS GUY! FLY FREE!

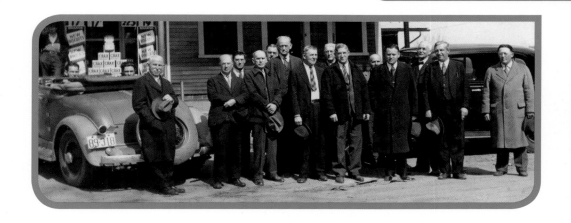

"THAT'S THE LAST TIME WE FALL ASLEEP IN THE CAR..."

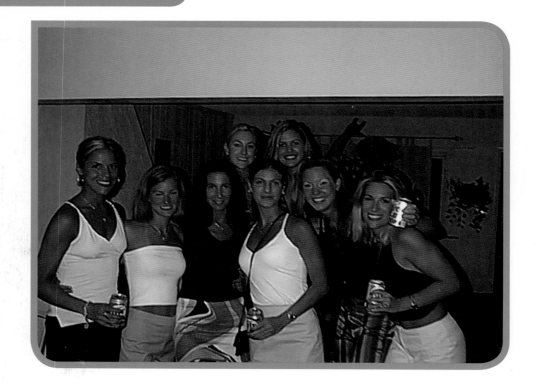

JUST ONE OF THE GIRLS.

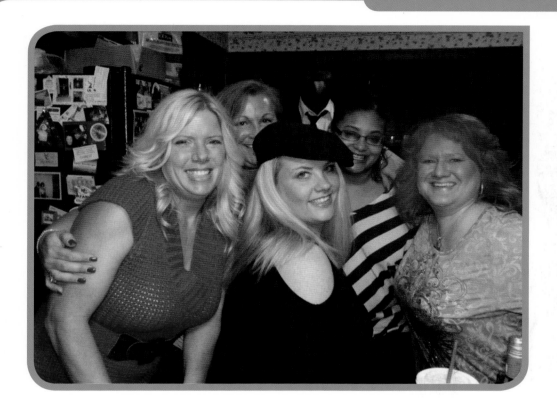

GENE SIMMONS WOULD BE PROUD OF THIS GUY!

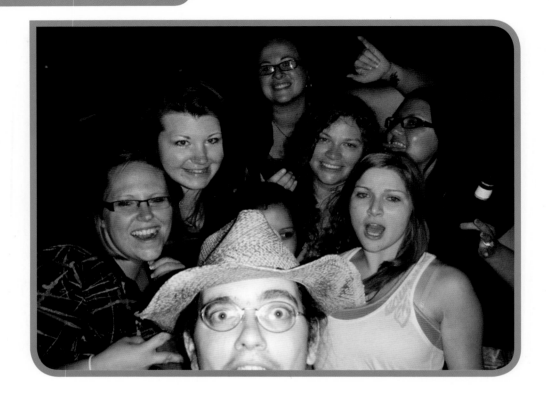

NOT EVERYONE CAN PULL OFF A TINY STRAW HAT,
BUT HE SOMEHOW MAKES IT WORK.

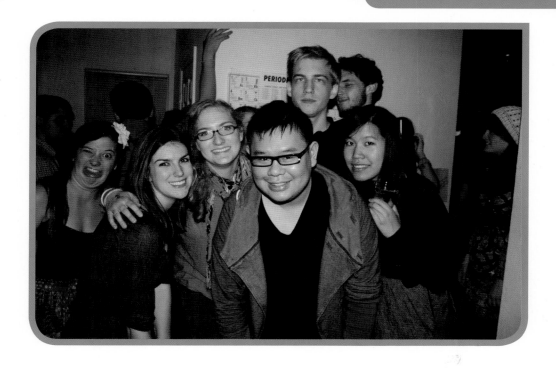

SHOULDN'T SHE BE LOCKED IN AN ATTIC SOMEWHERE?

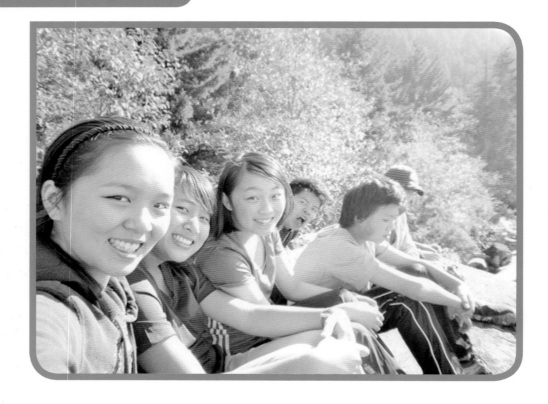

CLEARLY NOT A NATURE LOVER.

not bombs

Let us say first and foremost that our readers really came through for us and sent us tons of incredibly awesome photobombs. We got so many that we couldn't even use them all, which is totally special and really got to us right *here* *tapping heart*. However, not all of the pictures that we received made the cut for this book; in fact, not all of the pictures that we received were even photobombs at all.

Since *Oddee* has such a large, multicultural audience, it goes without saying that some things might get lost in translation from time to time, which is really the only way we can explain why someone might send us a picture of a goat wearing a hat, or a baby's mangled birthday cake. Still, it's the thought that counts, so we decided to dedicate this final chapter to the utterly random acts of photography that we have rightfully dubbed, "Not Bombs." Thanks but no thanks, right church, wrong pew, and so forth.

Enjoy the randomness…we certainly did!

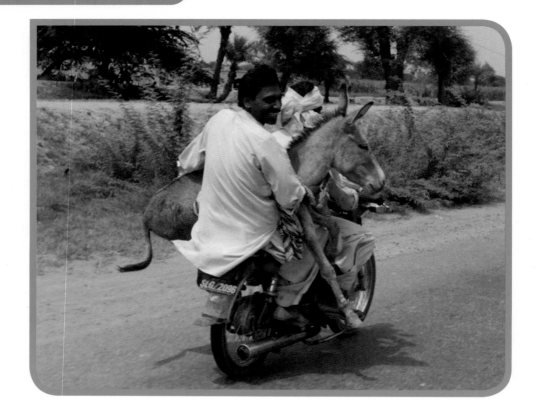

MINUTES LATER, HE FELL RIGHT ON HIS ASS.

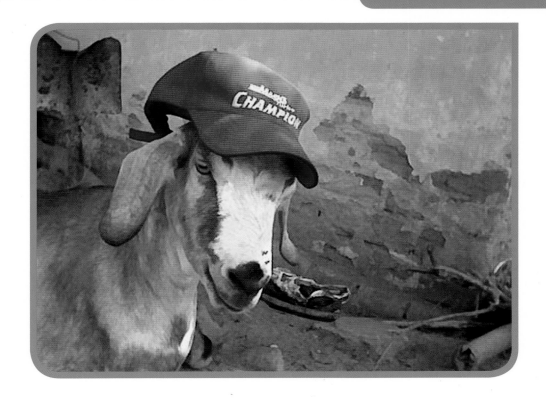

EVEN THE GOAT LOOKS LIKE HE'S ASKING,
"WTF IS THIS CRAP?"

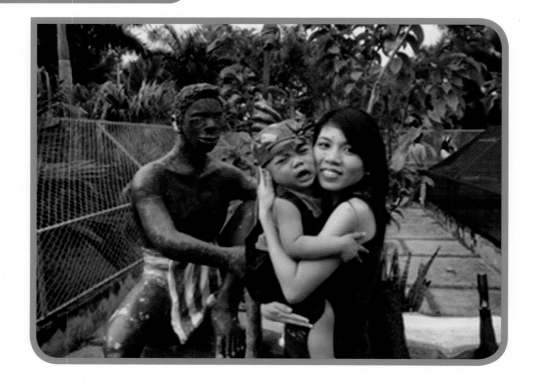

SON, IF YOU KEEP MAKING THAT FACE,
IT WILL STAY THAT WAY.
JUST LOOK AT THAT GUY BEHIND YOU.

A KICK TO THE GROIN = ALWAYS FUNNY!

WE PREFER OUR HOUSES BAKED,
OR PERHAPS LIGHTLY SAUTÉED.

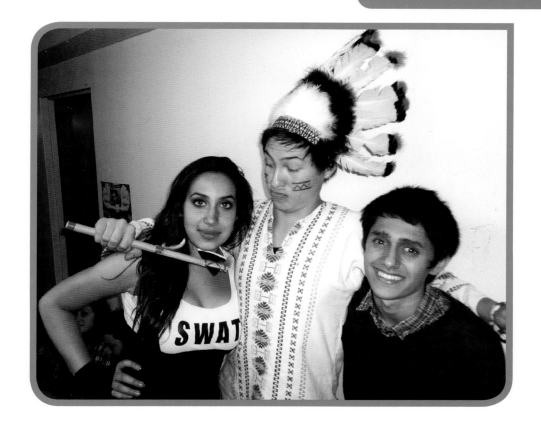

CHIEF TA-TA APPROVES.

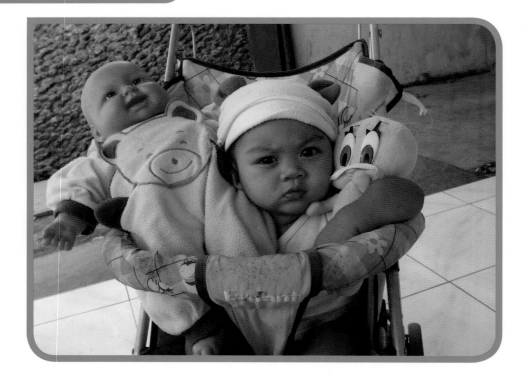

QUICK! GUESS WHICH ONE HAS A LOAD IN HIS PANTS.

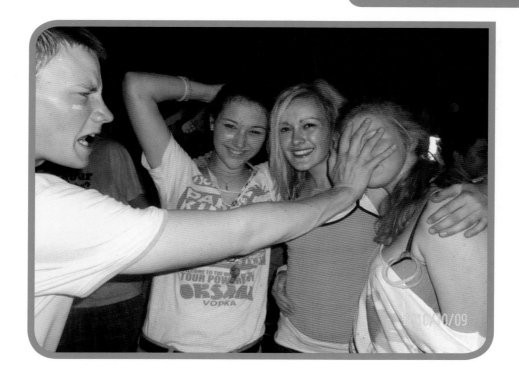

NOPE.

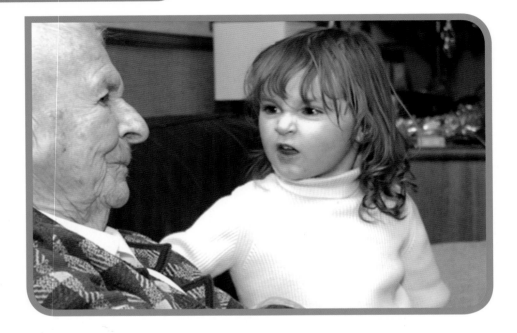

GRANDMA COULD USE A NEW SET OF TWEEZERS!

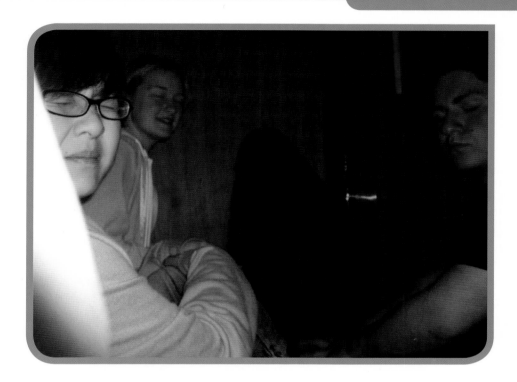

WE LOVED HER IN *THE RING!*

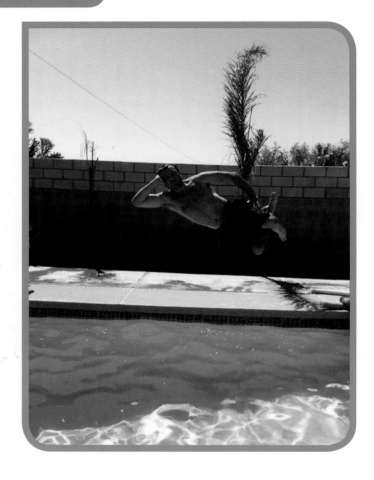

"SCREW YOU, GRAVITY!"

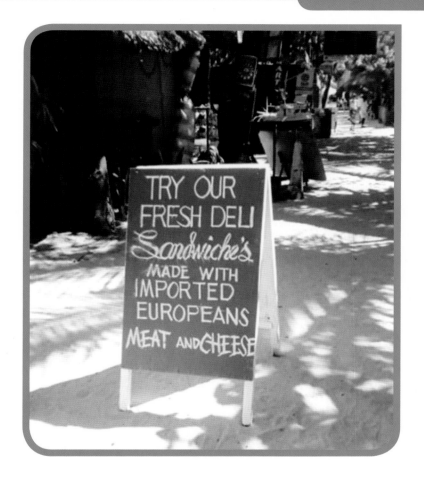

MMM, EUROPEANS ARE DELICIOUS THIS TIME OF YEAR.

acknowledgments

I would like to thank the following people for lending their support, vision, and talent in making this book a reality: Nahum Dam, our very own Internet entrepreneur, who is responsible for creating *Oddee* and making it one of the most popular entertainment blogs online. *Muchas, muchas gracias* to Graciela Murano, *Oddee*'s talented editor-in-chief and my favorite virtual coworker ever. Thanks to all of the writers and editors who work hard every day to make *Oddee* a fun, informative, and highly addictive online destination!

On behalf of *Oddee*, I'd like to extend a huge thank-you to our agent, David Fugate at Launchbooks, whose keen eye and extensive industry experience served us well on our road to publication. We're eternally grateful to our editor Peter Lynch and his team at Sourcebooks for bringing our idea to life. We would also like to thank Buck Wolf and David Moye at *HuffPost Weird News*, Avi Abrams at *Dark Roasted Blend*, Gerard Vlemmings at the *Presurfer*, and Miss Cellania and Alex Santoso at *Neatorama* for helping us get the word out when we were collecting photobombs.

On a personal note, I want to thank everyone who encouraged me and had my back along the way, especially Jim and the boys; Doug and Wanda Linzer; Deborah and Andrew Smith; Bob and Terry Jenkins and the whole gang at Jenkins South; Mala and Joe Tyler;

Laurie and Mark Laizure; Jill and Ric Dagenais; Mary Wagner; Frank Irwin; Brian Herrington; Kara and Aaron Dambroise; all of my Facebook pals; and last but not least, my Hestias.

Most importantly, we'd all like to thank the readers of Oddee.com for their loyalty, good humor, and generosity.

 # about the author

Beverly L. Jenkins is an award-winning television producer and director, freelance writer, and social media specialist. She currently contributes to a variety of print and online publications. Her first book, *Crap I Bought on eBay* (with Cary McNeal) was published by Running Press in October 2011. Learn more about Bev on her website, www.blinzerjenkins.com.